TEIGNMOUTH
THROUGH TIME
Viv Wilson

AMBERLEY PUBLISHING

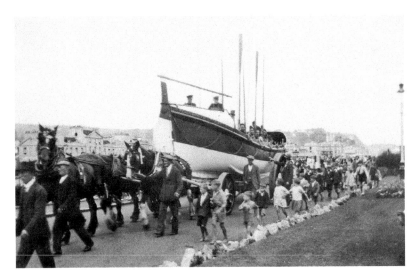

Teignmouth Lifeboat *c.* 1935

First published 2009

Amberley Publishing Plc
Cirencester Road, Chalford,
Stroud, Gloucestershire, GL6 8PE

www.amberley-books.com

Copyright © Viv Wilson, 2009

The right of Viv Wilson to be identified as the
Author of this work has been asserted in accordance with the
Copyrights, Designs and Patents Act 1988.

British Library Cataloguing in Publication Data.
A catalogue record for this book is available from the British Library.

ISBN 978 1 84868 558 1

Typesetting and Origination by Amberley Publishing.
Printed in Great Britain.

Foreword

Arriving in Teignmouth with my husband in 1967, we found a traditional seaside resort, with a Pier, sandy beach, a sea front, green and a wide promenade fronting a stately crescent of Georgian and Victorian hotels and guesthouses. Some areas of the old town still bore the scars of the war and decisions were made then to redevelop the road network sweeping away narrow streets and small fishermen's cottages to be replaced with a dual carriageway, new apartments and a library. Opinions and priorities change over time and looking back those early decisions seem questionable at best.

Now the pendulum has swung back again with increasing demands that those in authority protect the fragile heritage of this lovely town. The historic Old Teignmouth areas around the quays and the River Beach have survived and are lovingly restored by residents who want to retain the town's distinctive character. Many of the Edwardian Villas in leafy residential neighbourhoods are now protected within conservation areas and the unique lifestyle down on the River Beach, with the old boathouses, quirky pubs, boats and traditional beach chalets are now secure. Sea defences have provided Teignmouth with the best promenade on the south coast. The town continues to attract visitors who appreciate the efforts made by everyone, councillors and residents, to manage change without compromising our unique family appeal.

Viv Wilson began recording the town in pictures and stories in 1986. The Wilson Archive now contains innumerable images that preserve the past and present for future generations. Her endeavours were recognized in 2004 when HM The Queen presented her with an MBE.

Councillor Sylvia Russell
Chairman Teignbridge District Council 2009-10

Introduction

'Temporara multantur nos et matamur in illis'
(Times change and we change with them)

Who said comparisons are odious? It is good to compare, note changes and check our progress. But this book is about much more than comparisons, and Teignmothians, no matter where they live, understand that this wonderful place is about much more than being a seaside town. Its existence as a holiday resort began to diminish in the 1960s and since then it has slowly, very slowly, tried to adapt to being a pleasant place to visit and shop.

I am cutting a wide swathe through the saved images of this little town, rather than confining the contents to obvious features or seafront locations. Many buildings shown in the earlier photographs are no longer standing. In pairing those up I have sometimes chosen to work with a broader scale or differing viewpoint, since a wider perspective can be illuminating and put the recent images into stronger context.

I make no apology for including so many dates as they will be useful to enthusiasts of local history in the future.

Working with photographs of Teignmouth invariably prompts endless thoughts of the past twenty-three years spent immersed in its history. It has been fascinating, a great privilege and, together with the moving images collected more recently, will remain the most important part of my life's work.

Viv Wilson MBE

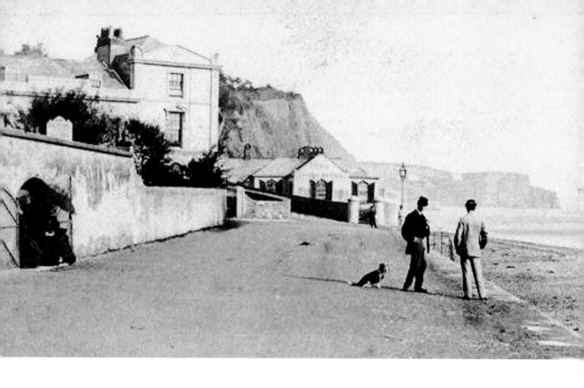

Esplanade c. 1870

The public baths at the foot of Eastcliff Bridge offered cold, hot or vapour immersions. Listed in a directory of 1836, the first owner, Mr Hubbard, built the sea wall joining the baths to the railway company's wall. The baths closed at the end of the 1870s. In the 1960s, the promenade café stood on the forecourt of Clifton House. This section of the sea front was dramatically changed by the construction of a high wall built 1990 to protect the town from the sea.

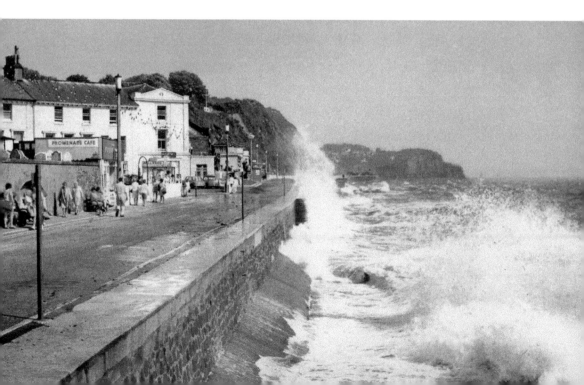

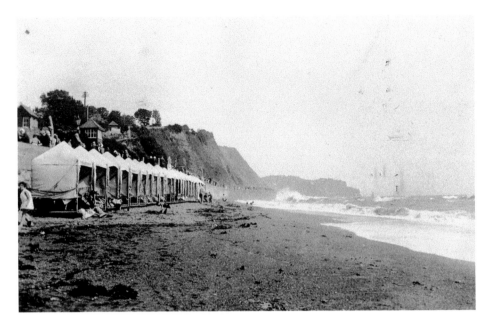

Eastcliff Beach, 1920s

Above the bathing tents, the coastguards' lookout is clearly seen, and, left, the whalebone arch at the southern end of 'Old Maid's Walk'. National Coastwatch was established in the old lookout tower in 2005. The railway bridge was shrouded in plastic for sand blasting in 2008. The recession blitzed the company, delaying completion of the task for a long period.

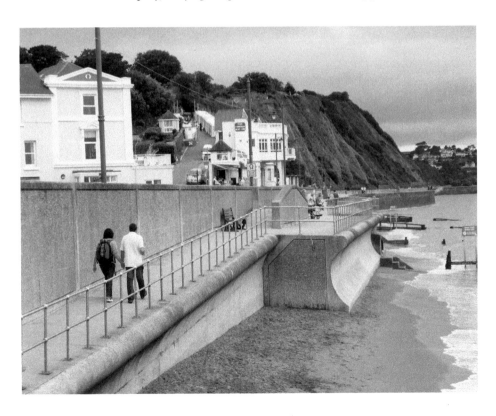

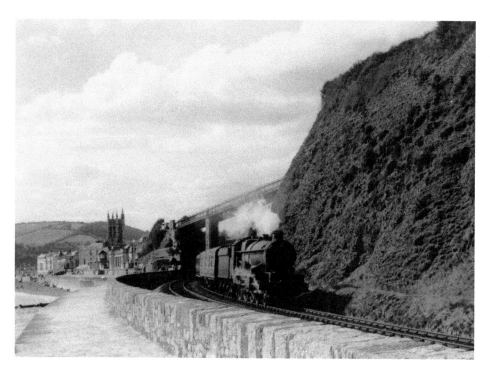

Sea Wall, 1950s

A steam train chugs under Eastcliff bridges, passing the wartime gun emplacement cut in the red rocks next to the line. Crowds assembled at Eastcliff bridges in 2009 to witness the first passing through of a new class of steam train. The plastic-enshrouded bridge makes a ghostly backdrop.

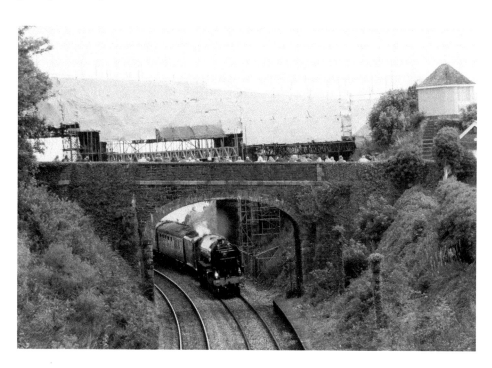

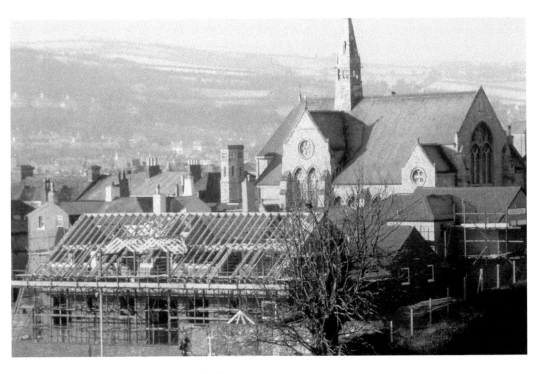

St Mary's Cottages from Eastcliff, 1986

The sheltered housing complex for elderly residents is administered together with Alberta and Bitton Court. St Mary's overlooks the Lido of 1974. Proposals to put a roof over the pool have not materialised.

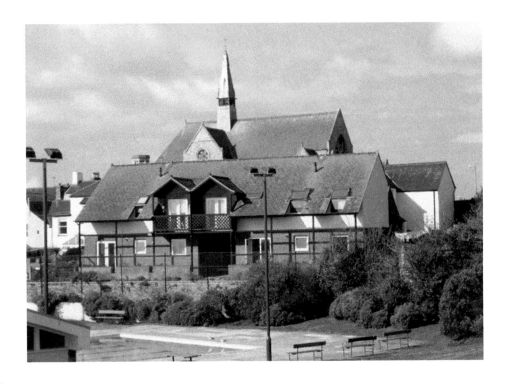

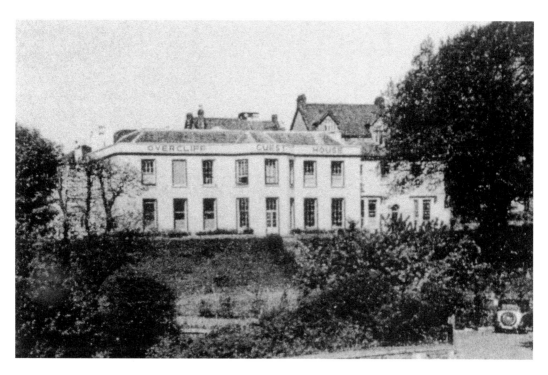

Overcliff Hotel, Dawlish Road, 1950s

One of the first large hotels to close down in the 1960s, the site became Eastcliff car and coach park. Remnants of the old walls and fireplaces can still be traced near the bus shelter. The large room above the 1960s public conveniences was Teign Corinthian Yacht Club HQ and, more recently, a youth centre.

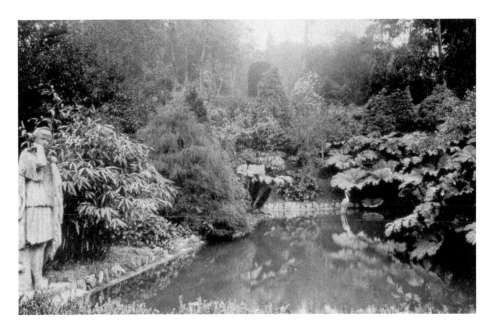

The Dell, 1926

The beautiful garden was created between Rowden House and Cliffden during the First World War. Belgian refugees helped with the landscaping of the valley, including a series of statuary-adorned ponds. Teignbridge Council has made the valley and meadows more accessible and staged theatrical performances and art exhibitions there. Mature trees and old hedgerows make it a natural haven for wildlife and plants.

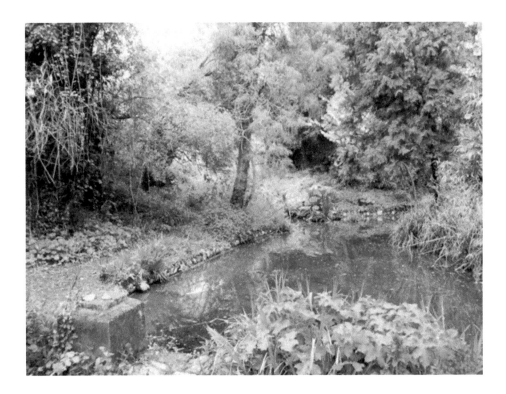

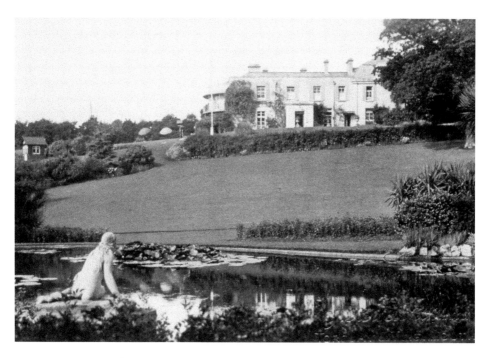

Cliffden, Dawlish Road, 1926

Every year up until 1983, a fête for King George V's Sailors' Fund was staged in the grounds. On carnival night there was community singing and fireworks. The Guide Dogs for the Blind Association opened it up as a hotel for blind people in 1990, and it is now run by Action for the Blind, which welcomes all-comers to Cliffden.

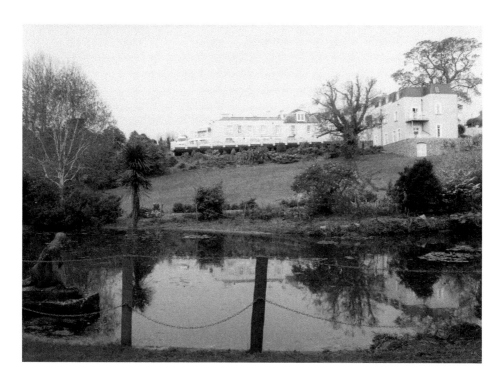

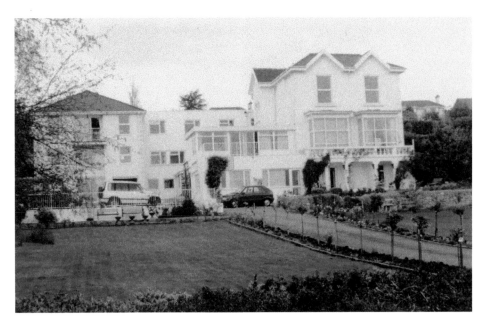

Burwood Lodge, First Drive, Dawlish Road, May 2000
A retirement home for many years, the staff cared for dementia sufferers. Changes in legislation affected such places and it was one of many that closed down. After demolition, Burwood Place grew up in July 2007, close to two other major developments along First Drive.

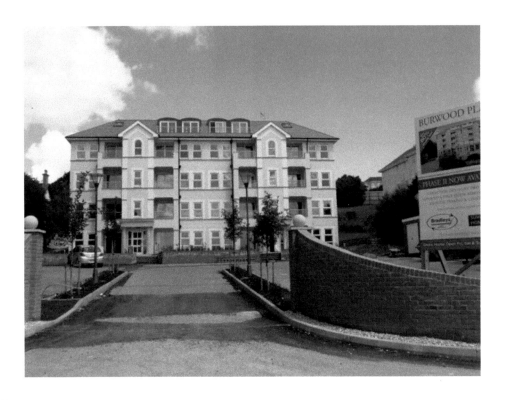

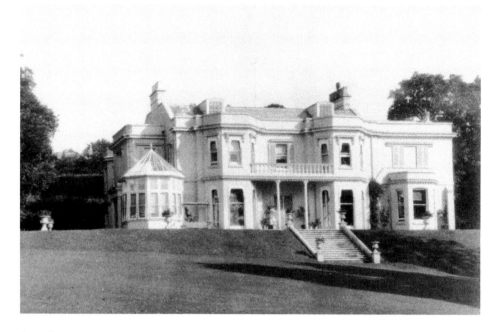

Rowden House, 1926

A house with the same name, destroyed by fire in the 1840s, lower down Dawlish Road was the childhood home of Charles Babbage. The inventor of a calculating machine now considered the first mechanical computer, Charles was Professor of Mathematics and married Georgiana Whitmore in St Michael's church in 1814. Rowden House was used as the Beacon School from the 1930 to the 1980s and was converted into flats in 1996.

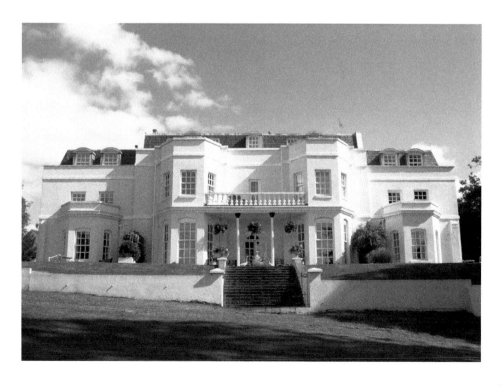

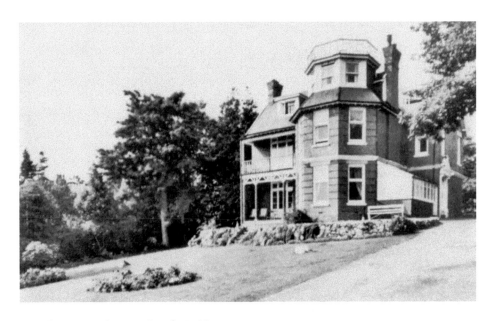

Woodway Hotel, New Road, 1960s

The author witnessed the demise of the hotel and neighbouring Uppercross in the autumn of
1993. The double site provided sufficient space for Higher Woodway Mews, twenty houses and
twelve flats with car turning and play space.

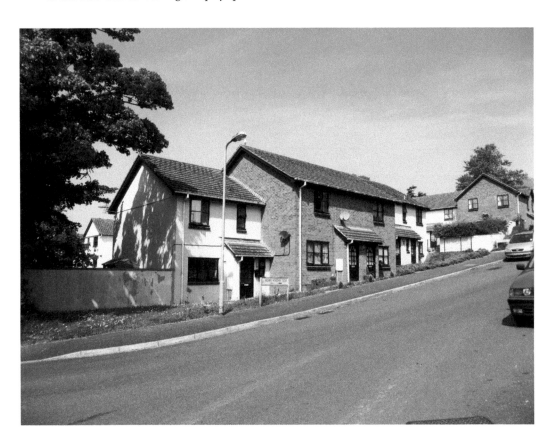

New Road, 2004

Kiniver Nursing Home for the elderly population was demolished for development. Kiniver Court rose rapidly from the ashes of the old place, a trend that was repeated in numerous locations in Teignmouth as the larger, expensive to maintain properties were being disposed of, or businesses ceased trading.

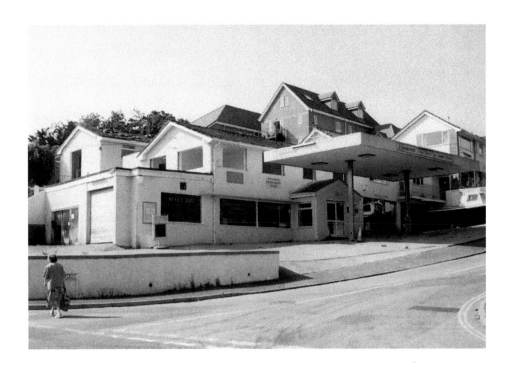

New Road and Maudlin Drive Junction, 2003

After years of providing convenient local services, the garage closed down and was demolished. The pastel shades of Trinity Mews town houses enhance the locality, which has absorbed many changes in the past decade.

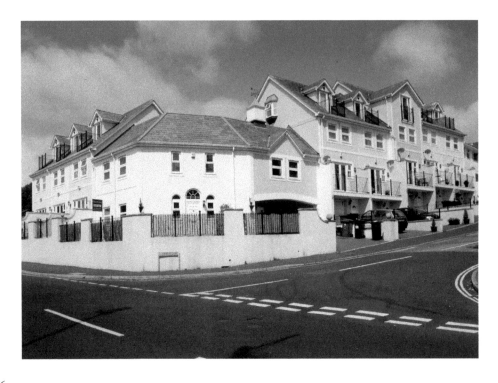

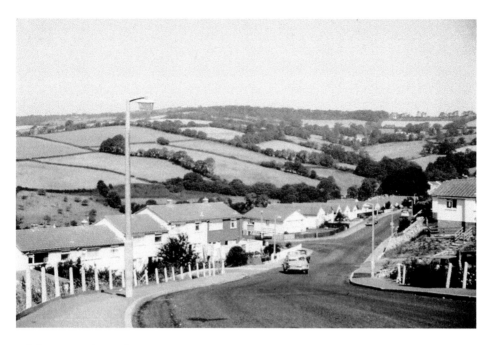

Higher Coombe Drive, 1970

The east banks of Coombe Valley were covered with new dwellings in the 1960s. Traffic was minimal and the surrounding ancient meadows and copses provided residents with a semi-rural lifestyle. Much of the far hillside disappeared in the 1980s as more housing crept up the west bank, and further development is likely.

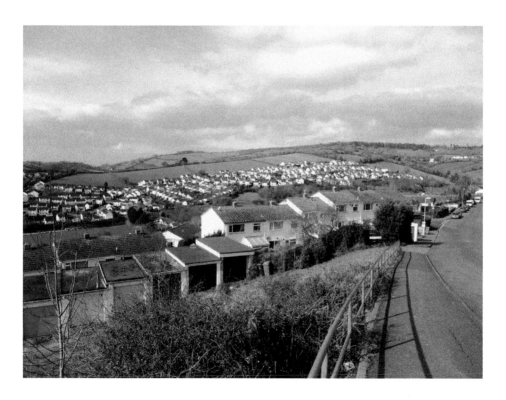

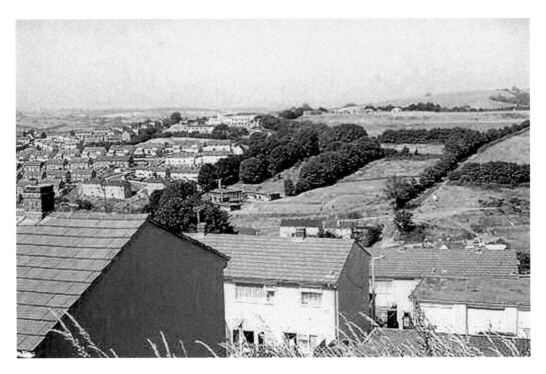

Across the Valley from Higher Coombe Drive, *c.* 1970

Our Lady and St Patrick's School (centre) was built on a one-in-four slope at the end of Fourth Avenue in 1967 and cost £260,000. Catholics from all over the region supported the five-classroom school, which has earned an excellent reputation. Through the 1990s, acres of fields and ancient boundaries in Coombe were swallowed up by 'progress'.

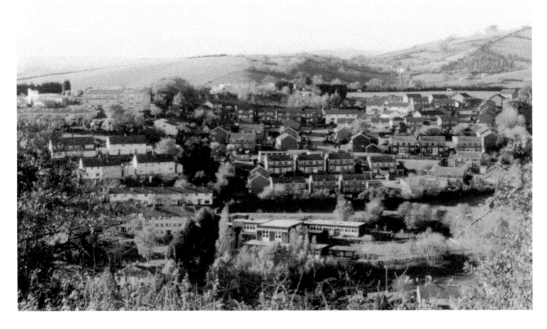

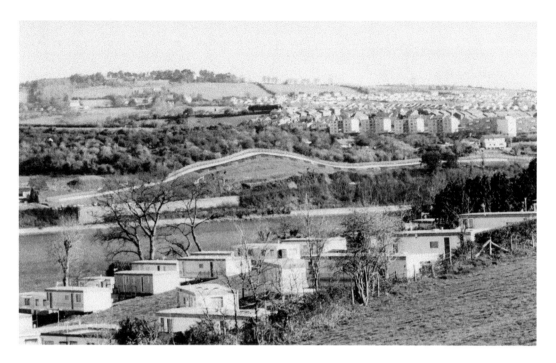

West Teignmouth from across the Teign, 1996

The shoulder of The Lea, rising above Broadmeadow, was cut back and the landscape scoured during road improvements between Broadmeadow and Bishopsteignton. Twelve years on, vegetation growth has softened the impact on the hillside where the long-established Baytor kennels finally closed down. Gabled roofs have been added to the Kingsway flats.

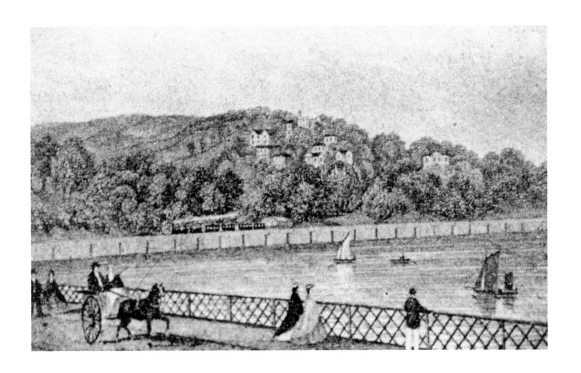

Shaldon Bridge in early times

Built between 1825 and 1827, the twenty-four-arch bridge cost £20,000. It was 1,672ft long with an opening span over the main river channel. The replacement bridge of 1931 was not strong enough to cope with increased traffic volume. After years of debate about another bridge, the 1931 one was strengthened in 2002.

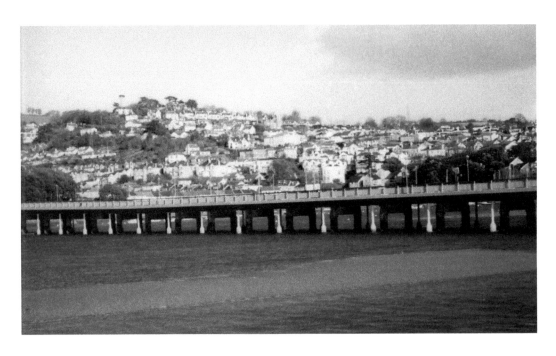

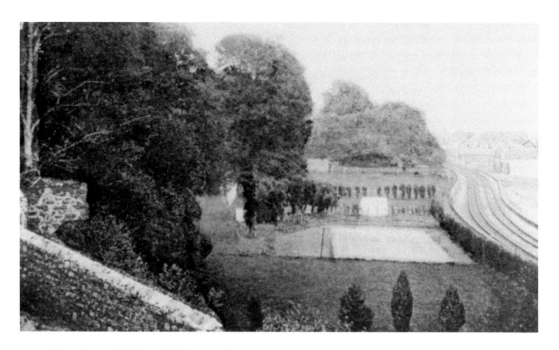

View from Shaldon Bridge, 1908

The Bitton Estate was owned from 1863 to 1899 by the Parson family, who gave land for the rugby and football ground, the tennis court being added later. The old drover's tunnel for farmers to take their animals safely beneath the original railway line was spoiled when the water authority laid a large pipe through it, but walkers still use it at low tide.

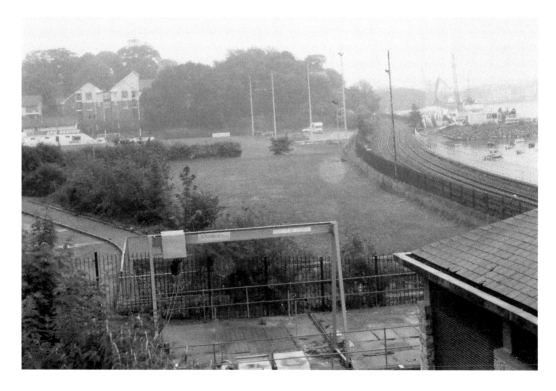

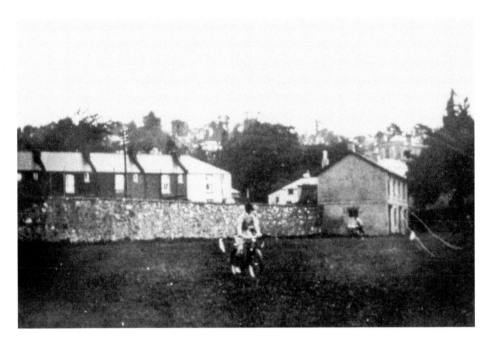

Rugby Ground, 1930s

The large space was used for school sports and gymkhanas, and assembly of the annual carnival procession. The Whispering Bells tea garden, run from the building on the right, became Teignmouth Rugby Club House. Many fine players were nurtured in the club. The damage caused by a tornado in 1984 gave rise to many improvements and new building.

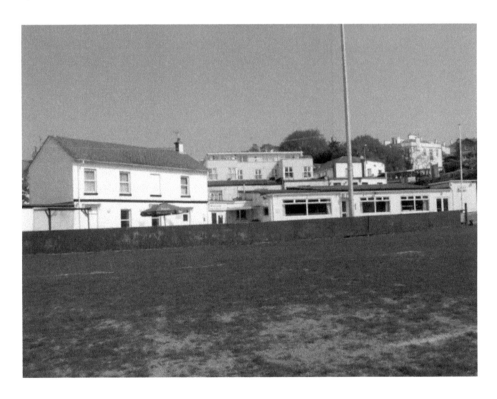

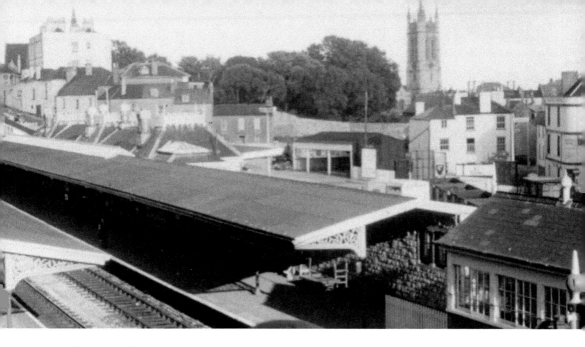

Railway Station, 1964

Numerous forges, sawmills and workshops for plumbing and painting were part of the station complex in the nineteenth century when the railway company employed about 150 local men and boys here. Residents complained about sulphurous fumes and sent a petition to Parliament about the noise from the steam hammer. Today, it is difficult to imagine the noise and grime of the old workshops that stood behind the station in the early days of the railway company.

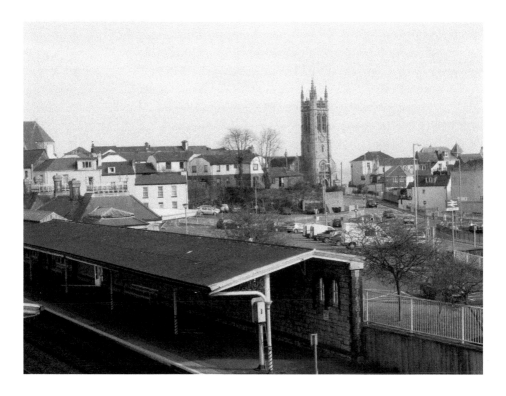

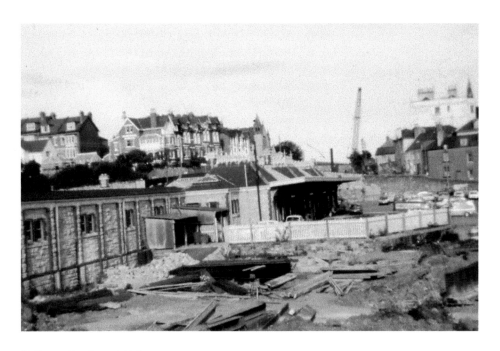

Railway Station, 1974

The first train arrived at Teignmouth on 30 May 1846 to a band playing and crowds cheering. The new station, built of limestone in 1893, cost £18,000. Alberta Mansion is on the skyline, right. The foundation stone of 1893 is now displayed beside the large anchor next to the dual carriageway crossing to Station Road.

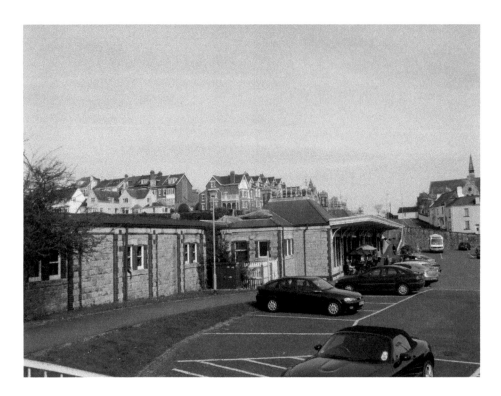

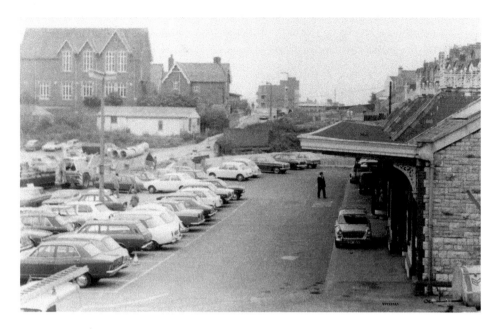

Station Yard, 1972

Up to the 1960s, hundreds of railway workers poured in from Swindon for their holiday every summer. Brook Hill School, in its last years, breaks the skyline. The giant supermarket's £5 million plans of 1997, for a 25,000 sq ft store with 17,000 products, eventually came to pass on the old school site.

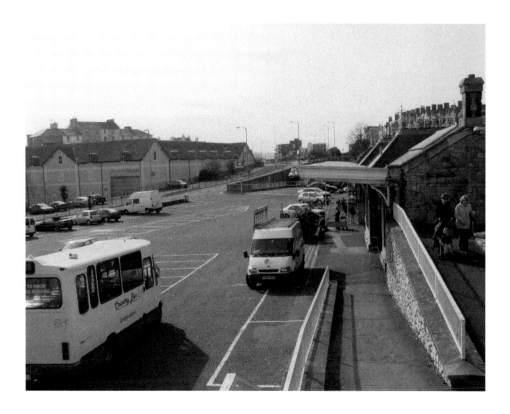

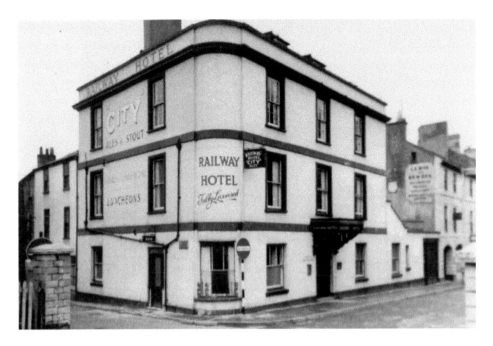

Station Road, 1960s

The fine limestone gateposts marking the entrance to the original enclosed station yard are seen here. The Railway Hotel would soon become a victim of the new dual carriageway. The three-storey building in the centre of the recent image, became the end of the terrace. The Masonic Lodge, left, was extended in 1999.

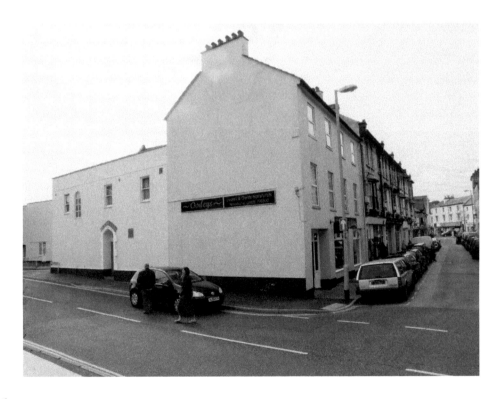

Up Station Road, 1970

The old police station was demolished and a large supermarket built in its place. One of the red granite plaques recording the town's historical connections is attached to a building at the top. Small businesses showed signs of struggling soon after 2000, with empty premises acting as indicators of the lead-up to the current global financial recession.

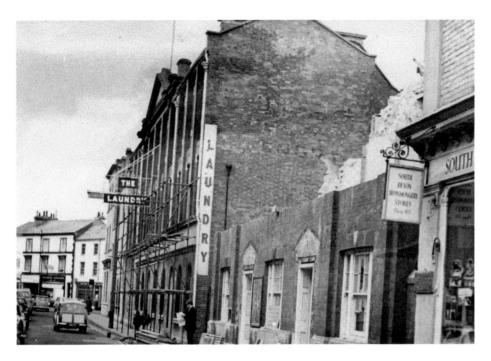

Station Road to Triangle, 1970

Demolition of the old police station next to the laundry is underway and a large supermarket will soon dwarf the individual character of the other shops lining this road. Nearly forty years on, the premises have changed hands several times, moving from food sales to a clothing outlet.

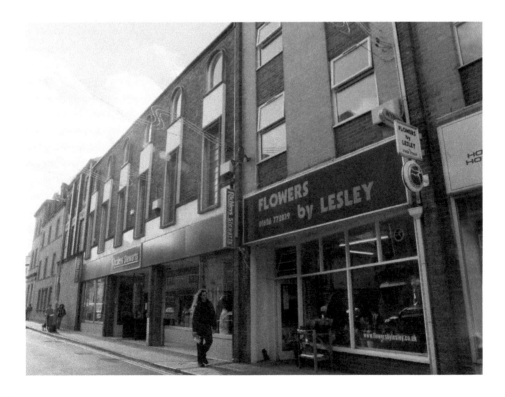

Myrtle Hill, 1974

Massive strengthening panels were installed to support a one-way traffic system. The United Reformed church stands next to Alberta Mansions, arranged in flats for the final years of its life. The wall, though utilitarian, has proved efficient in protecting the railway line by carrying the huge increase in traffic for over three decades.

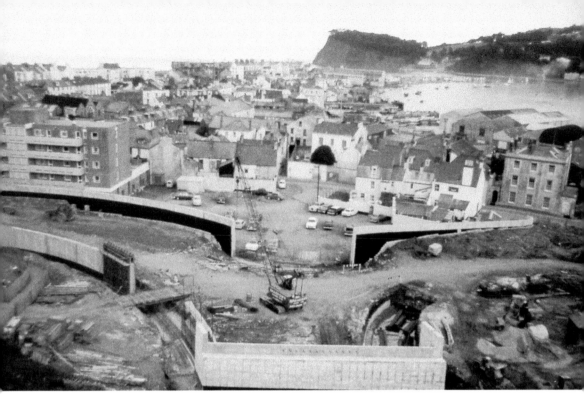

The Teign Street Area, late 1960s

The Teign Street area was exposed during construction of the first phase of the dual carriageway. The slip road on the right leading off to the docks is seen in the more recent image. The old buildings on the quays, swept away in the 1980s, were replaced by much larger transit sheds.

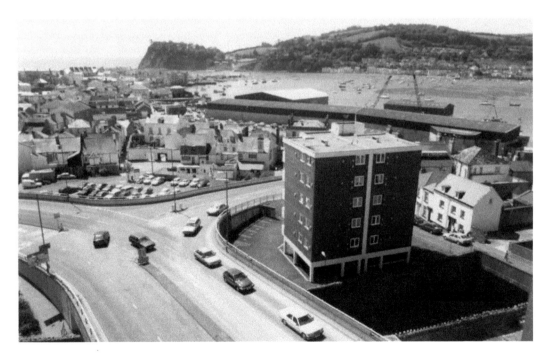

Teign Street, 1950s

At the turn of the twentieth century, the town crier and three porters mingled with wandering tradesmen hawking watercress, pasties or French onions. Romanies sold pegs and told fortunes and tramps lodged in the street. Musicians brought cheer and the barrel organ was stored in Saxe Street. Still bursting with character, this busy little gem of a street retains individual businesses, appreciated by locals and tourists.

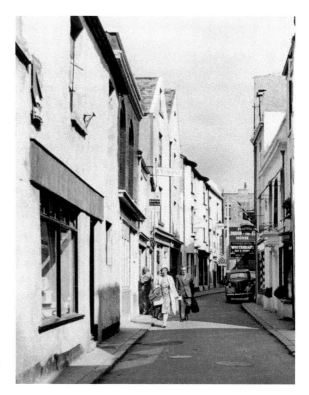

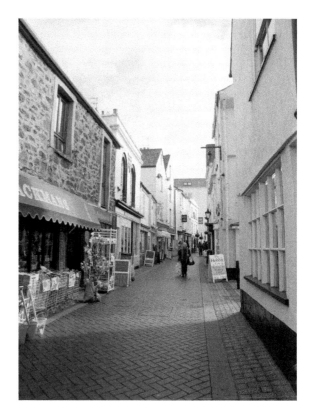

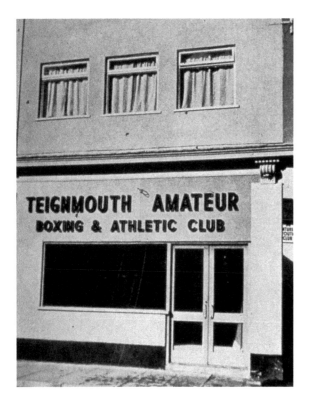

Somerset Place, 1973

The former Lyceum cinema was bought by the council in 1946 for £2,000. The rear was rented to the ice company for £1 per week. The boxing club, established there in the 1970s, was opened by Henry Cooper. In its street setting next to the Methodist church, a travel company operates in the front part and the old ice factory has become a much-needed community centre.

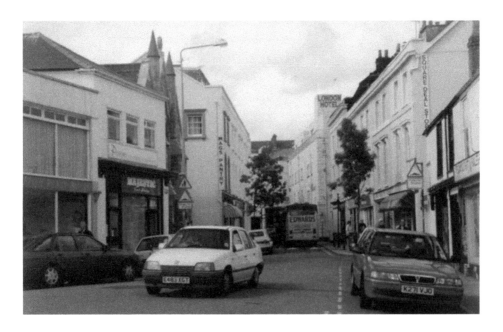

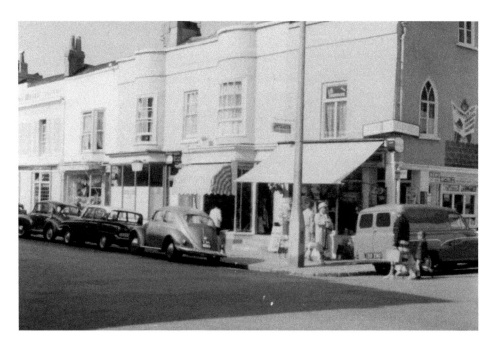

Northumberland Place and Quay Road Junction, 1964

The Georgian fronts and gently bowing windows make this a visually pleasing area. Rat Island nearby was cut off at high tide and in living memory, Mrs Belton pushed a sales cart along here calling 'Cock-les! Muss-els! Wink-les!' Recent tree plantings and wider pavements, introduced by the enhancement scheme of 2006, led the way to the street café culture.

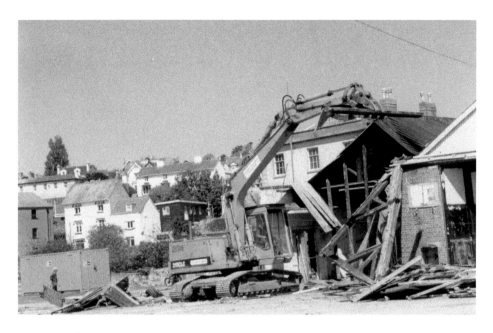

Quay Road, May 1997

Many young local men learned their trade in Bulley's boat yard on this site. Plans to build a supermarket on this site in the 1990s changed and instead a new 170-space car park was created, fulfilling a desperate need for parking. Teignmouth House, centre, was the fishermen's mission from the nineteenth century until the Second World War.

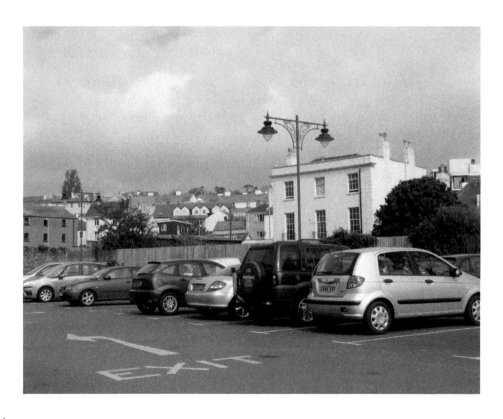

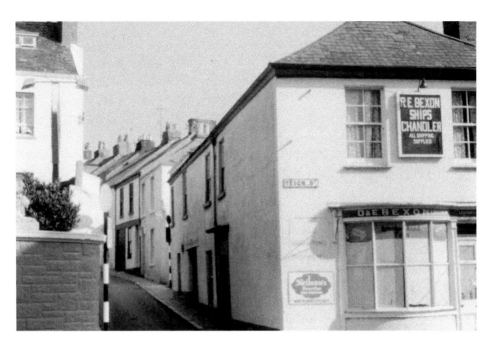

Parson Street and Quay Road Junction, 1960s

Bexon, the ships' chandlery is right and Regia Hotel, with its line of distinctive windows set into the roof, left. Parson Street flats were built in the 1960s. Regia Hotel ran as an antique centre for a few years but closed in 1998. After an uncertain outlook, it was converted into flats.

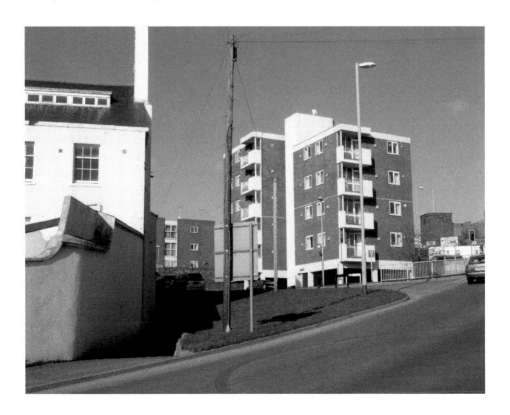

Willow Street, February 2005

A builders' store for several years, it was sold and the developer followed the trend of building a block of flats. The northern boundary of the railway line is now dotted with new flats. Plans for twenty-nine apartments on the Job Centre site got underway but the scheme appears to be resting on the horns of the recession.

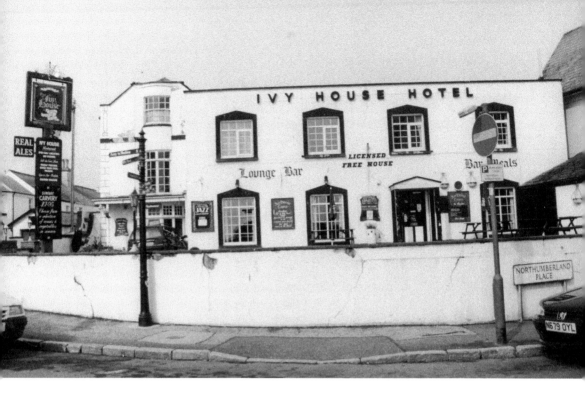

Ivy House, Northumberland Place, 2004

A popular live music venue was lost when Ivy House was demolished in September 2004. The old part of the building (left) in Ivy Lane was incorporated into the development. Nearing completion in 2006, ten flats were created by the project.

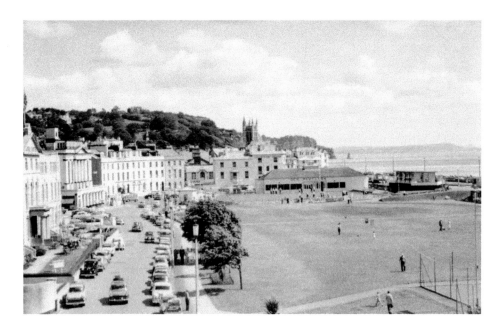

View from the Bay Hotel, 1950s

Battalions of riflemen drilled in open and closed columns, quick time and at the double in front of hundreds of spectators in the nineteenth century. Landscaping was increased on the Den in 1912 using soil from road widening schemes at Mill Lane and Bishopsteignton Road. In 2006 a huge barn was erected for building of the *Spirit of Teignmouth*, a 68ft world-class trimaran. Simon Chalk's plans to sail the vessel around the globe failed and the barn was removed the following year.

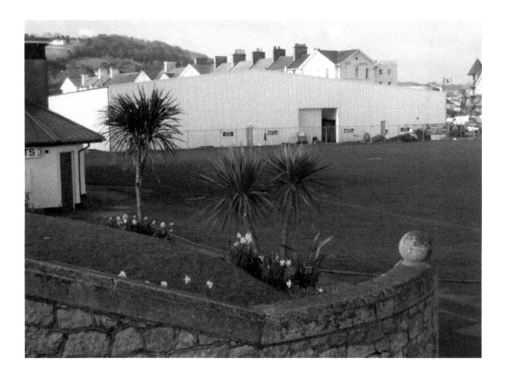

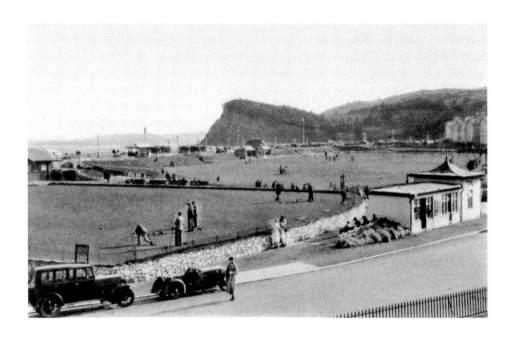

Information Bureau, the Den, 1930s

Established by Teignmouth Publicity Committee, it was a boon for visitors, wooed here by outstanding records of sunshine hours averaging 1,703 annually between 1906 and 1935. The TIC, upgraded in 1992, continues to disseminate literature and handle ticket sales.

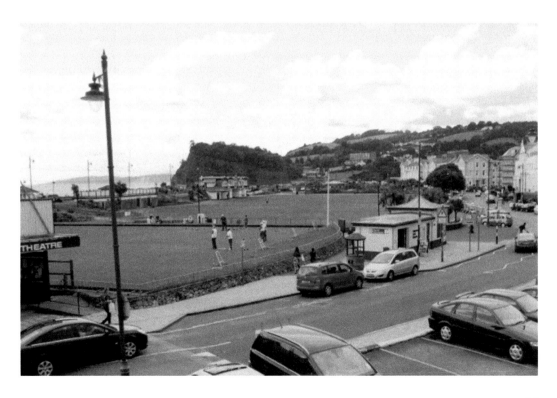

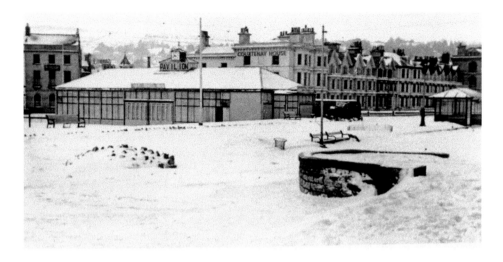

Den Pavilion, 1947

Teignmouth UDC borrowed £3,425 to build the 885-seat pavilion of glass and iron, opened June 1930. Joan Plowright appeared here in a play in the 1950s. After extensions in 1967 to provide dressing rooms and a front foyer, it was renamed Carlton Theatre. Its utilitarian exterior is constantly criticised but it has had a stay of execution since the 1980s.

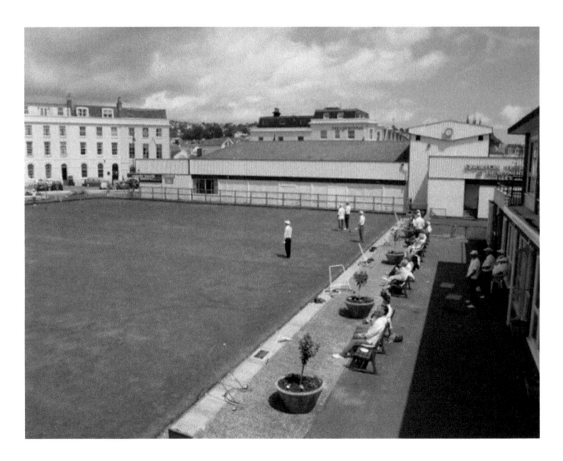

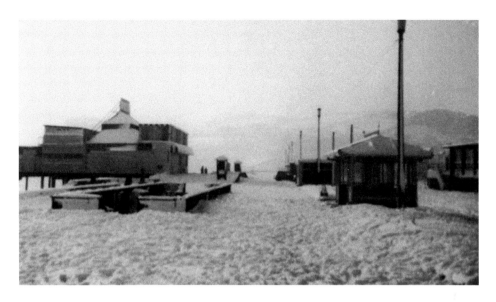

The Promenade, 1963

Fairy lights between the lighthouse and Jubilee shelter, the illuminated sunken garden and anti-dazzle paving slabs are all pre-war features still in place during the record-breaking winter. Replacement of the sunken garden with raised beds in the 1990s is one of many changes along the promenade but Teignmouth can still boast its free-of-toll pier.

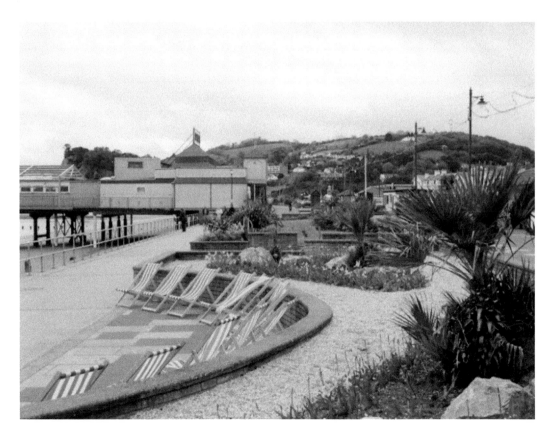

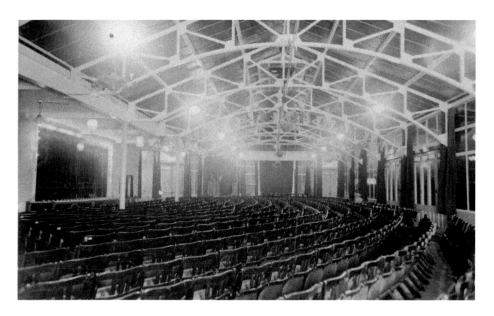

Den Pavilion, 1930

The first stage was on the east side. Large windows overlooking the Den (right) caused high temperatures so the glass was painted green but that made people feel nauseous. It was used as a mess by US Seabees in 1944 and a plaque they made at the time is now displayed in the front foyer. Teignmouth Players, taking the lease in 1986, constructed the tiered section and the Butler Bar. Resisting several council proposals to demolish, a more positive outlook for the future currently prevails.

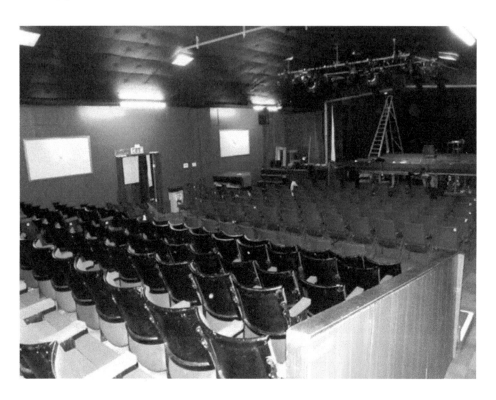

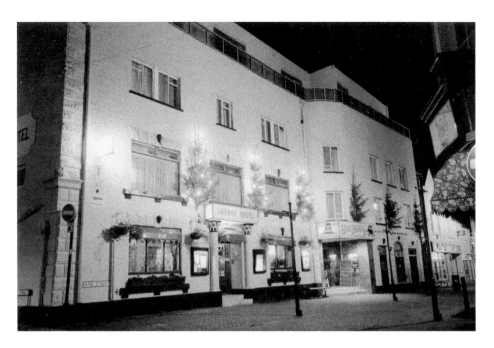

London Hotel, Bank Street, 1993

A former coaching house, it boasted a top storey swimming pool in the 1970s. The ballroom's sprung floor of maple was in regular use when dancing was the townspeople's most popular pastime. After closure in 2005 it was converted to fifteen apartments and renamed Charlton Court. New residents include local people, a former town mayor and a buyer from abroad.

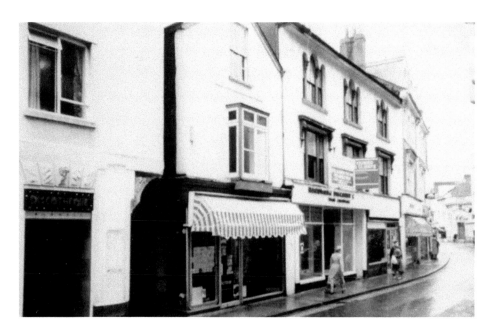

Bank Street, December 1983

The two shops were demolished in the following year. The door on the left was the fire exit for the London Hotel's first floor ballroom. Bank Street was a marshy place until the town was improved by a major drainage scheme in the eighteenth century and the Tame Brook was contained below street level. Even now, the cellars of some of the shops are notoriously damp.

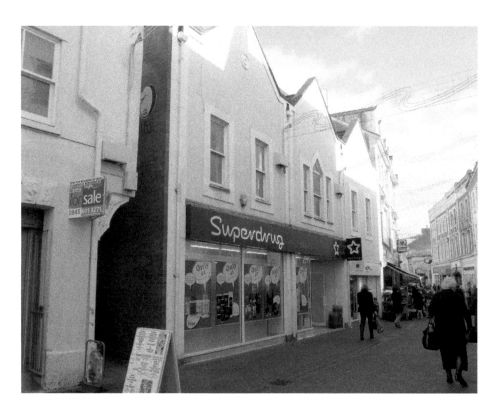

Bank Street, 1970s

At the time of the French invasion (1690) the only business was a bank, operating on this site that became number 7. Pioneer aviator William Parkhouse sold Gypsy Moth aeroplanes from here in the late 1920s, succeeded by F. W. Woolworth. The original display windows enhanced the street, traffic-free from the 1990s. Bank Street lost its largest retailer after the shock closure of Woolworth stores nationwide in January 2009.

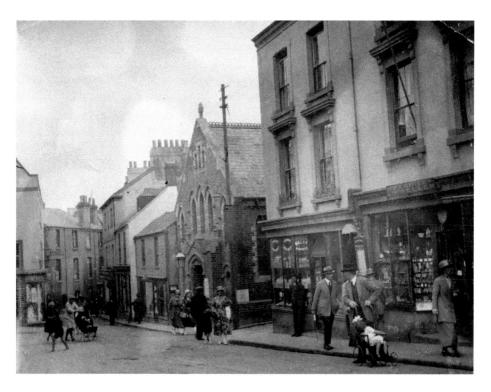

Fore Street, 1930s

Commercial Road ran between the Baptist church and the little corner shop attached to Pedrick the jeweller. Most of Fore Street was demolished in the 1960s but the Baptist church exterior has changed very little. The extra floor added to the former London Hotel, now Charlton Court apartments, is clearly visible.

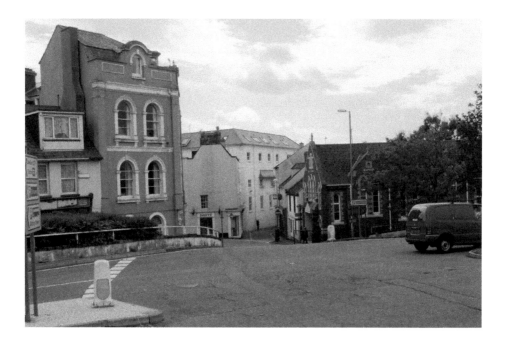

Higher Brook Street, 2005

This site was earmarked for a new fire station a decade earlier. Concerns that proposals to make the dual carriageway narrower would create problems for the fire engine led to a public enquiry in 1997. Teignmouth's new £600,000 Fire & Rescue Station was officially opened in February 2006.

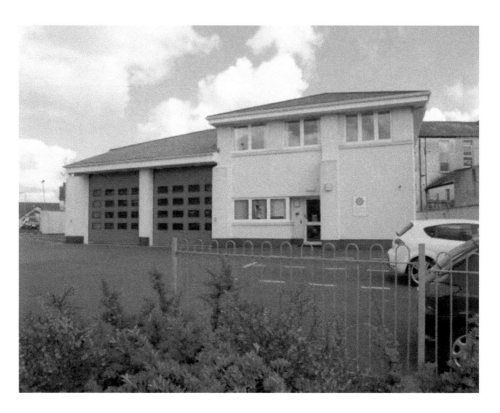

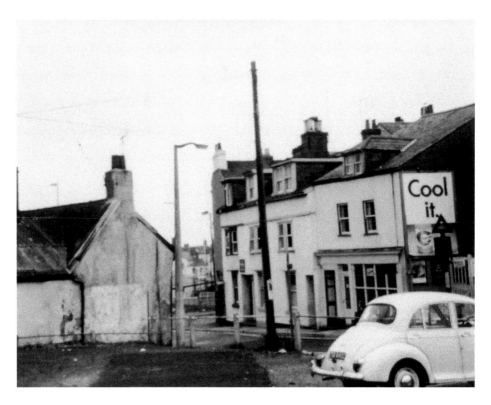

Higher Brook Street, 1971

Fragments of local memories include Godfrey's newsagents and the alley leading up to Dodd's fish store. Primary school teacher Miss Best lost her mother and sister when their home nearby was bombed in 1942. The building on the left is all that remains from the 1971 image and can be identified (centre) in the overview from Salisbury Terrace, prior to the building of the fire station.

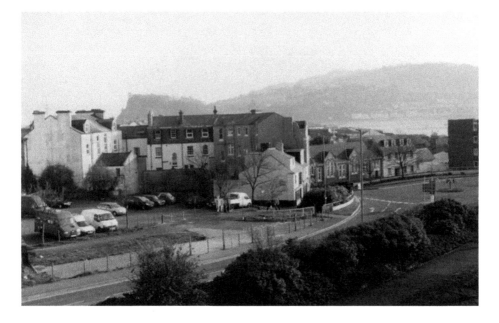

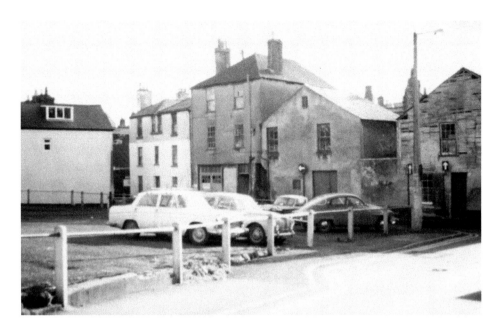

French Street, 1973

The tall store became Teignmouth Museum in 1978. Much is owed to the small group of enthusiasts who got the museum off the ground and subscribed to the concept of preserving our past for the future. Grants from the National Lottery and SeaCabe will lead to construction of a £1 million extension. The anchor and other external artefacts were relocated nearby to make way for the new building, due to get underway this year.

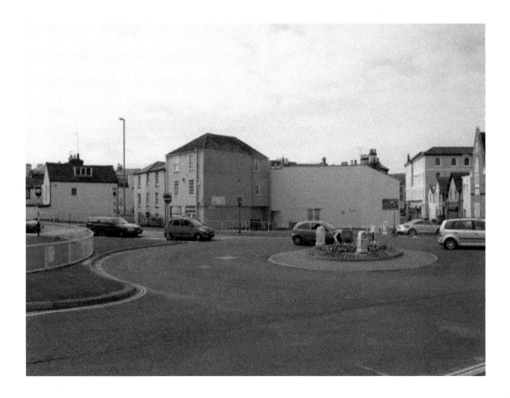

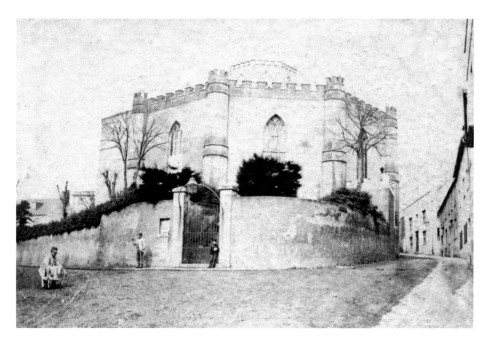

St James the Less c. 1890

This six-sided church for West Teignmouth, consecrated in 1821, has a thirteenth-century tower. Black's guidebook of 1872 declared it 'ugly' and in the worst possible style. In the past, the funeral bells were rung once for a man, twice for a woman and thrice for a child. The tower, one of Teignmouth's oldest structures, was re-pointed in medieval style in the 1970s.

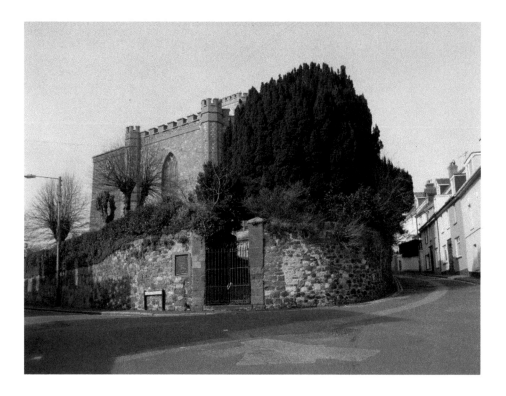

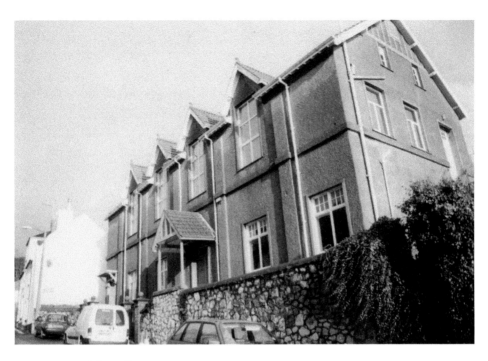

St James' Parish Hall, 2001
In Exeter Street, next to the former West Lawn School buildings, the hall served the community well and its demise left a vacuum. The gabled features of the old hall are reflected in the cluster of town houses built on the plot.

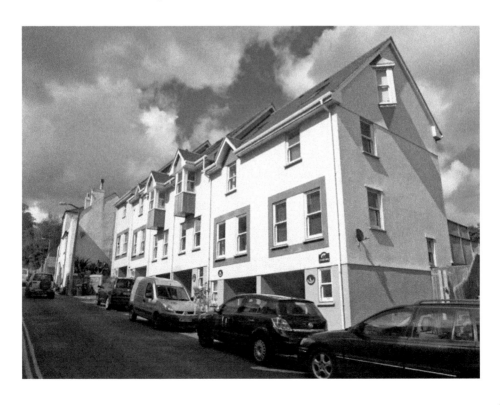

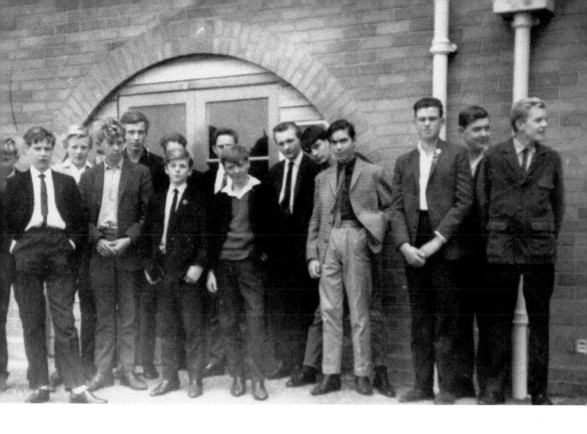

West Lawn School, 1965

These pupils of the County Secondary School, built in 1911, did not have to pay for their education like their predecessors. The secondary modern merged with the grammar school and the complex was renamed Teignmouth Community College in the late 1980s.

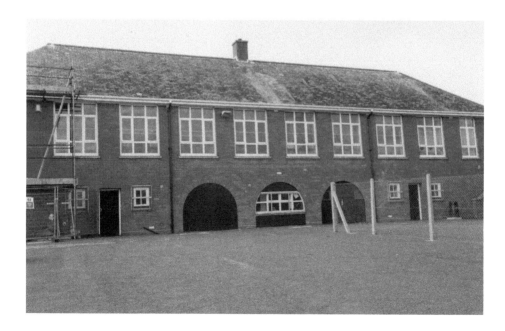

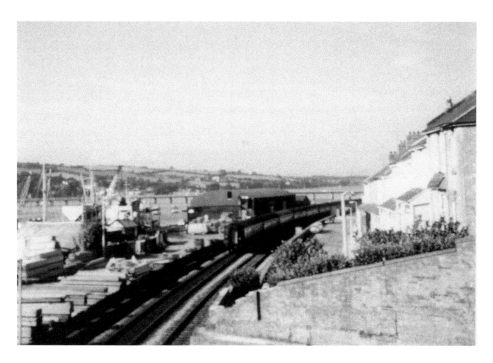

Western Dock and Alexandra Terrace, 1971

The view from Clay Lane shows stacks of timber next to the railway line but the port also handled coal, animal feed, paper, slates and chipboard. Modernisation brought new, large transit sheds, changing the face of the docks forever. Clay has always been one of the most important exports from Teignmouth.

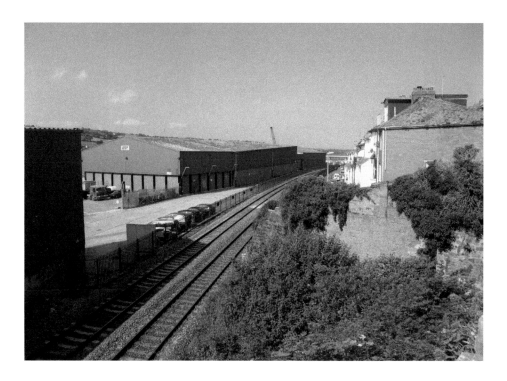

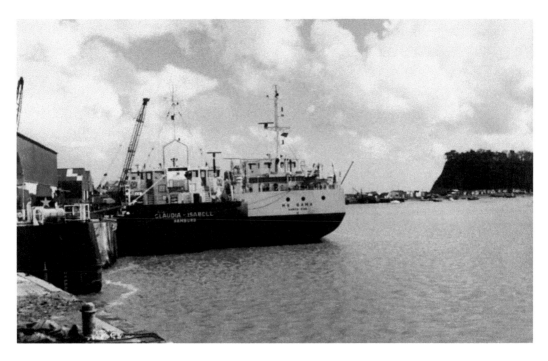

Polly Steps, 1980s

The launching slip and car park were created from hardcore, cut during the construction of the dual carriageway in the late 1960s. Two ships moored side by side, as in the top image, was once common practise. Teignbridge Council and the docks company combined to provide a 30 metre stretch of river bank for additional winter storage of leisure craft during the reshaping programme of 2005.

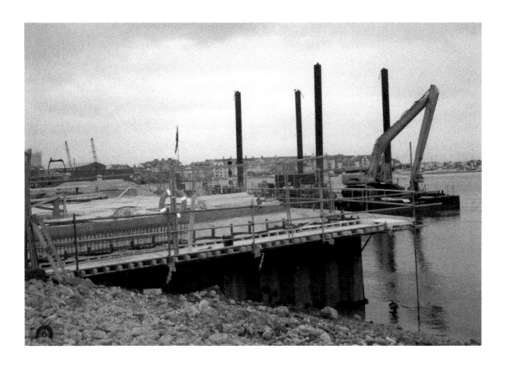

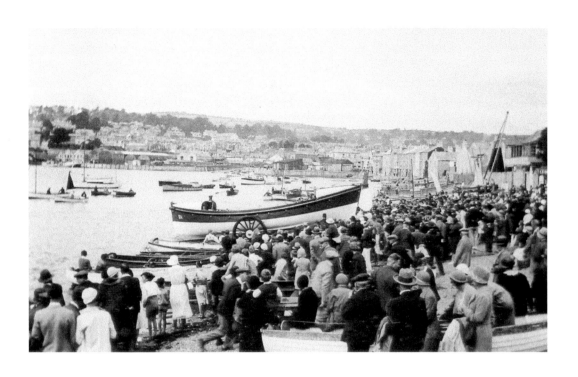

Teignmouth Lifeboat, 1930s

A crowd awaits the launch of the *Henry Finlay* into the river Teign. The crew inexplicably numbered thirteen men. The current lifeboat – *The Two Annes* – requires a crew of four. This inshore B809 Atlantic 85, dedicated to Teignmouth in 2006, is capable of high speeds.

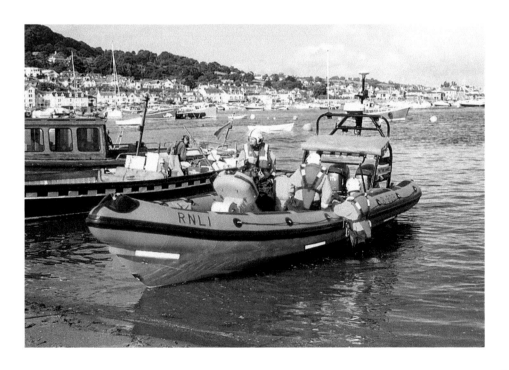

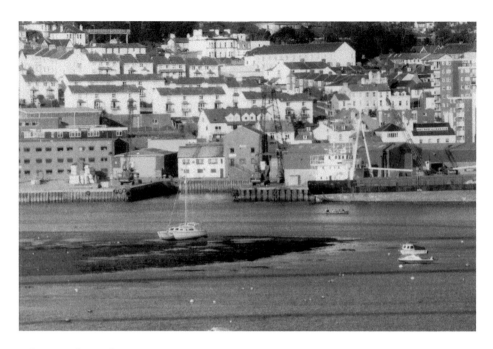

Teignmouth Docks, 2001

Opposition from local people failed to stop a £4 million expansion scheme. The original small docks (numbers one and two) have gone and new structures built in their place. The reshaping allowed for a straight frontage, enabling larger ships to moor in line. Fears that the change would affect the flow of the Teign appear unfounded.

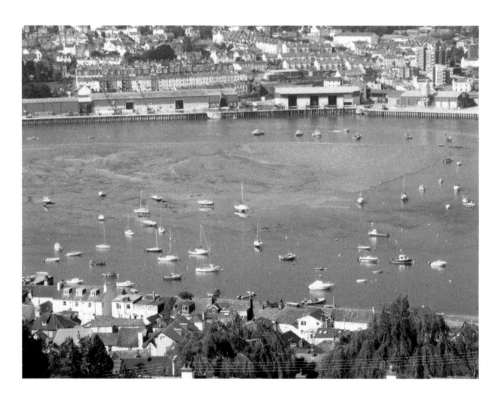

Happy Days Nursery, Broadmeadow, January 2004
The new century's fresh impetus to childcare and provision encouraged Kingsway Meadow Community Association to spearhead the scheme. Next to the sports pitches, redundant since the 1990s due to its earlier use as a tip, the ark-inspired nursery serves the community. The Den is used as the winter alternative for Sunday morning football matches for the young.

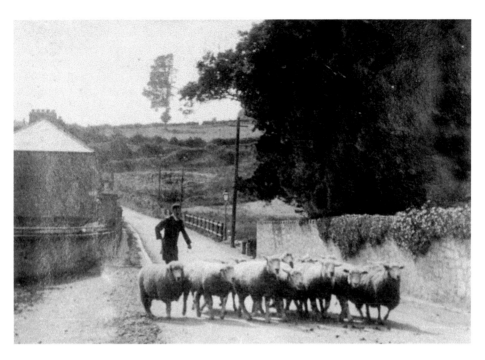

Newton Road, Broadmeadow, c. 1910

Sheep driven along highways was a common sight when the fields clothing the sides of the Teign estuary were in agricultural use. This photograph was taken close to the gasworks. The wall continues to form a boundary between Broadmeadow House and the main road.

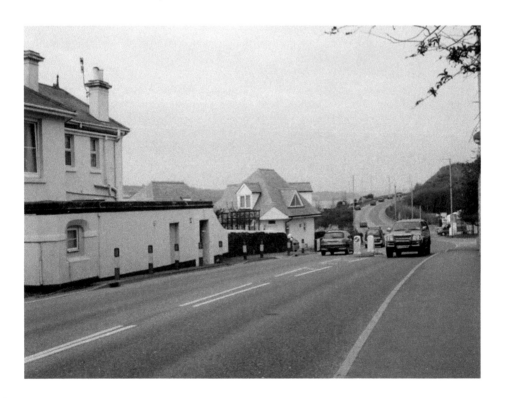

Bitton Park Road, c. 1870

The journeyman gazes towards the woman next to the boundary of Lower Bitton House. The broken wall may have been caused by the Bitton Brook. A Victorian terrace was built along the south side, and Leacombe, the cottage (centre), is a visual link between both images. The long-established garage business sold out to a supermarket giant in 2007.

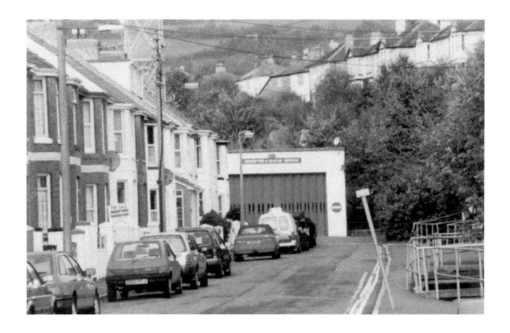

First Avenue, 1998

The fire station was built here in the 1950s after being based for some years at County Garage. The service moved to its new headquarters on Higher Brook Street in 2006. The old station was demolished and a new complex, appropriately named Phoenix Court, has grown up on the site.

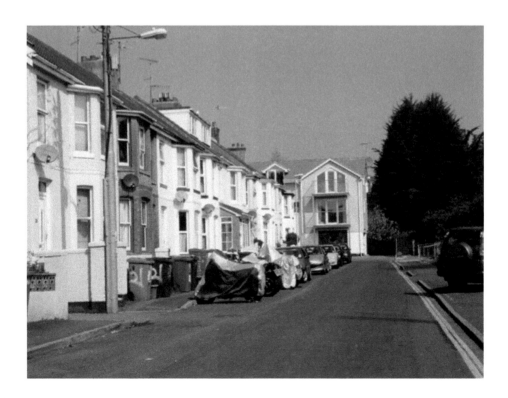

The Talbot Inn, Bitton Park Road, 1980s

A convenient hostelry for residents of West Teignmouth, it was damaged in 1984 when a thunderbolt rolled down the estuary. In its last few years, it was renamed the First and Last Inn. The site of the inn and car sales plot provided space in 2007 for Talbot Court to be built opposite Teignmouth Rugby Club grounds.

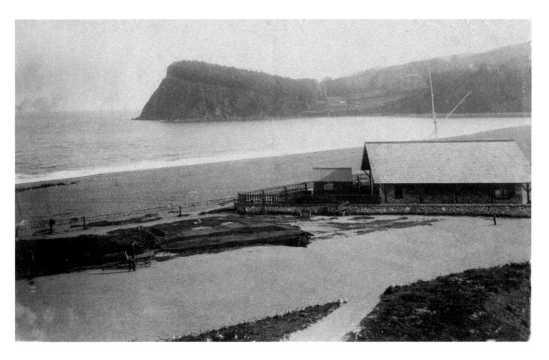

The Point, Nineteenth Century

The Lifeboat station opened in 1863 with the benefit of a barometer and a complete set of Fitzroy storm signals. It closed in 1940, seven lifeboats later. Re-established in 1990, the service is an enormous asset with sea and water sports more widely practised by larger numbers of people. Teignmouth has clocked up an impressive RNLI history.

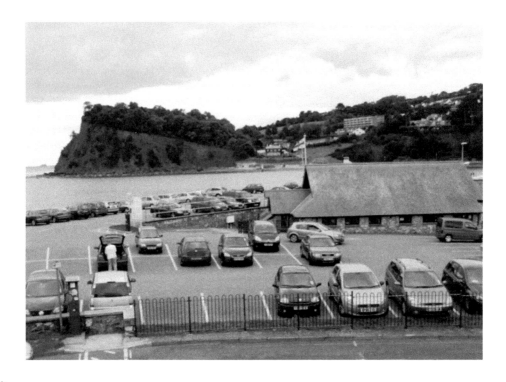

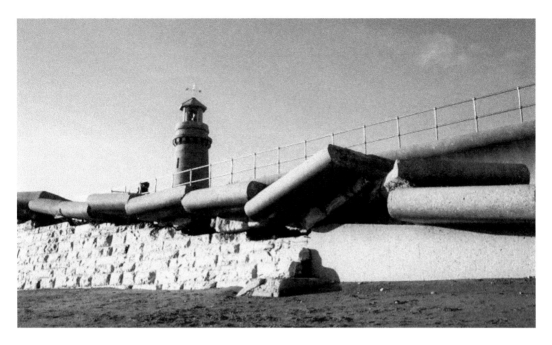

Lighthouse, December 2005

A vicious storm raged along the seafront attacking the slipway to west beach. Huge slabs of concrete were upended and the area cordoned off from the public. A repair programme got underway in less than two months and the link between the western promenade and the beach was restored.

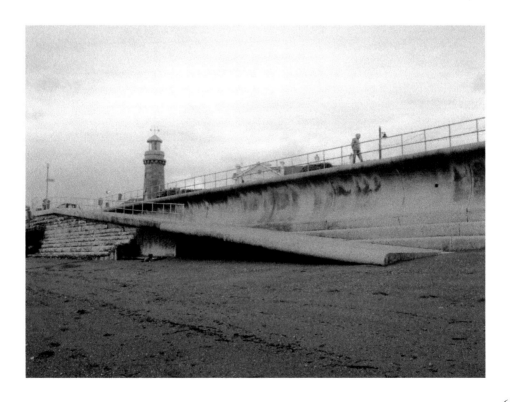

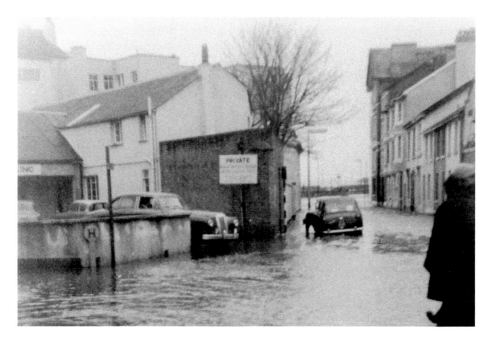

Brunswick Street Flooding, 1969

The lowest-lying ground in Teignmouth has experienced several bouts of flooding. The Royal Hotel garages, once serving as stables, were demolished in December 1997, prior to the main hotel. After demolition of the Royal Hotel in 1998, Royal Court, with almost eighty apartments, was developed, maximising the whole site except for a store facing Bath Terrace.

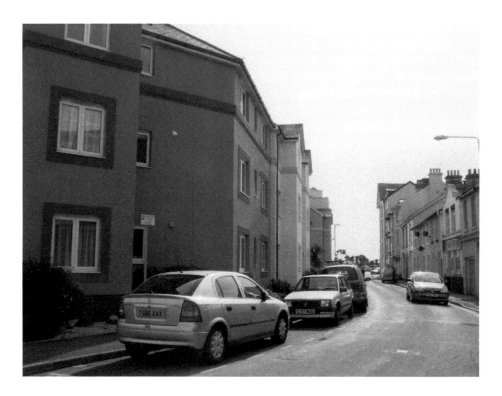

Market House Inn, Brunswick Street, 1920s
One of Teignmouth's thirty-one public houses, it became Lewis & Rowden sale rooms and closed in 2005. The Victorian Local Board offices and market hall of 1883 were destroyed by enemy action in August 1942. The remaining fragment of the original building is a public convenience (left). The image of the shoppers' car park dates from the 1970s.

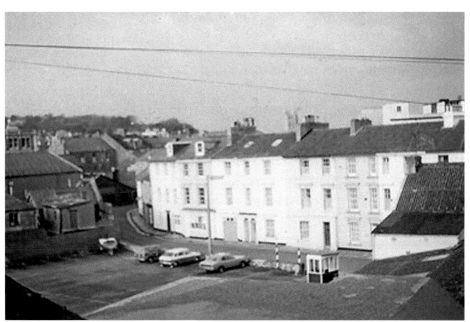

Carlton Place, 2002

After closing in 2003, the Magistrate's Court was centralised to Newton Abbot. The 1960s building had an interior mish-mash of black vinyl, timber panels and an ultra-modern plasterwork feature. A local building firm gutted the building and converted it to St Joseph's Court in 2007.

The new Triangles, 1995

Pedestrianisation of The Triangles complete, Councillor Don Tracey, mayor of Teignmouth, performs the official opening. Fountain Court, a £1.5 million scheme of fifteen apartments was completed in 2008.

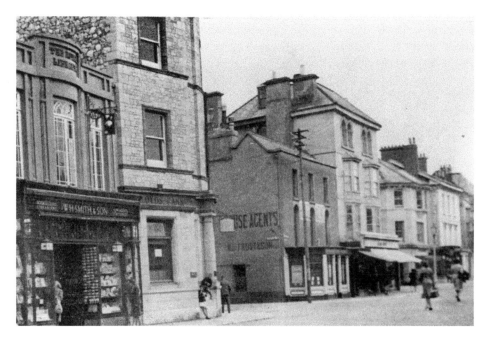

The Triangle, 1950s

Triangle, 1950s. Gas lighting was still used in the streets in this decade – note the lamp, right. Some had timers but the rest were lit by hand every day in the year, the last lamplighter was Fred Niblett. The Royal Library's upper floor is a reminder of nineteenth-century elegance. The corner building that had been a bank from 1924 changed to a solicitors' office in 1999.

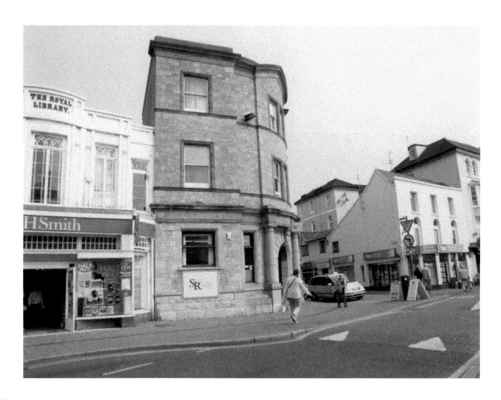

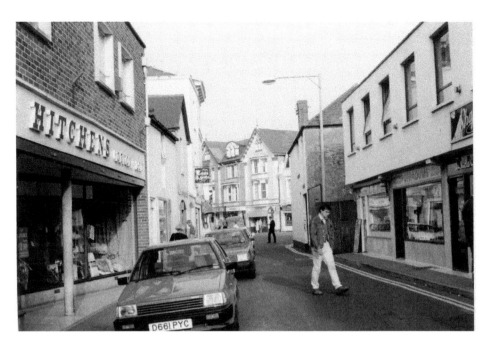

Waterloo Street, 1994

Waterloo Street, 1994. Traffic orders restricting day time flows were about to change the nature of the street named after the historic victory over Napoleon in 1815. The demise of Hitchens, the favoured walk-through clothing and haberdashery store brought great sadness and much more than trade was lost by its closure. New surfaces improve the area for pedestrians.

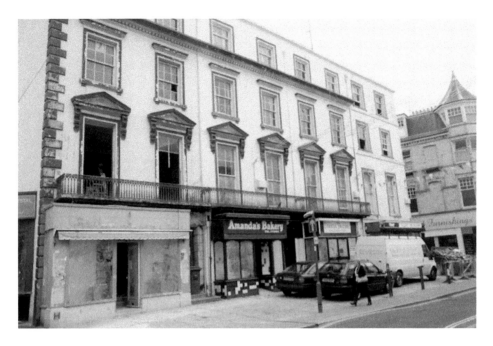

Wellington Street, October 2003

Originally Wellington Row, it was named after the Duke who put paid to threats to our country from Napoleon at the battle of Waterloo in 1815. The street has an air of neglect but improvements of 2007-8 elevated this elegant terrace, complimenting other improvements and adding finesse to the town centre.

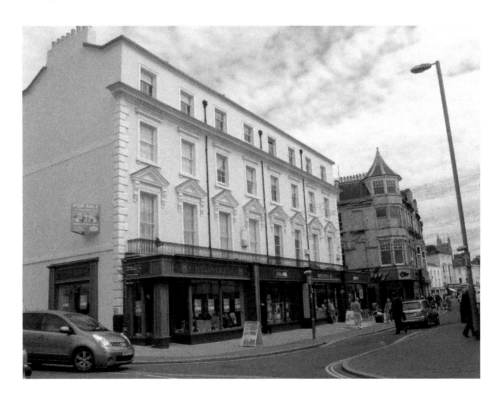

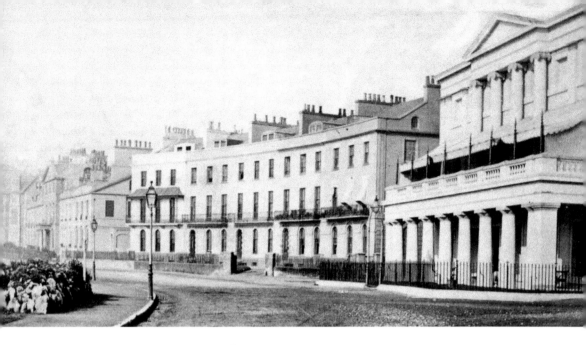

Riviera and Den Crescent, early 1900s

Built by public subscription in 1826, this magnificent building commemorated the achievements of Sir Edward Pellew at the battle of Algiers in 1817. The cinema, split horizontally in the late 1960s, closed in 1999. Owned by the Prince family for the previous seventy-one years, the Riviera was sold and five apartments built above the auditorium. A new restaurant and café bar opened in 2009.

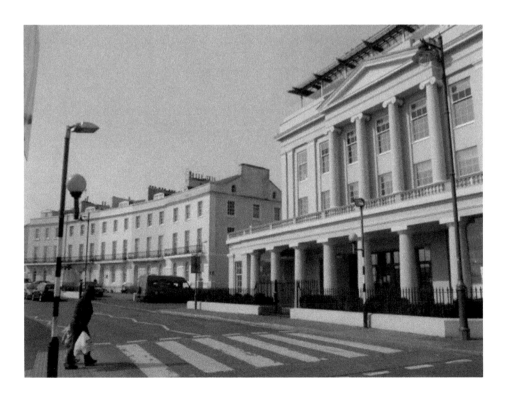

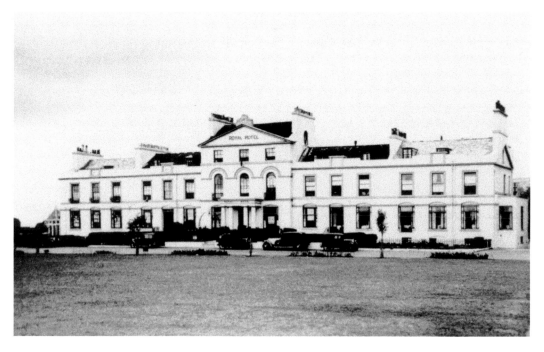

Royal Hotel, 1920s

Used by the Royal Navy and US troops in the Second World War, Winston Churchill held D-Day meetings here. Whilst filming *Magical Mystery Tour* in 1967, The Beatles were greeted by 5,000 local teenagers. It took six months to demolish, in 1997-8, and six years passed before developers started work on Royal Court.

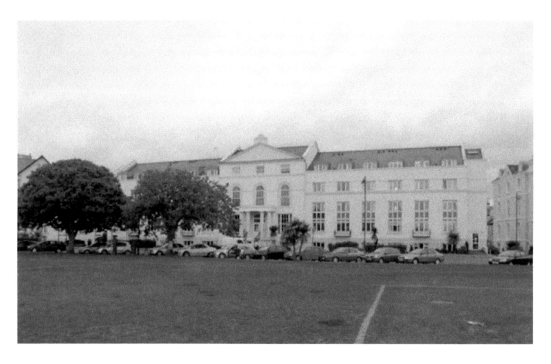

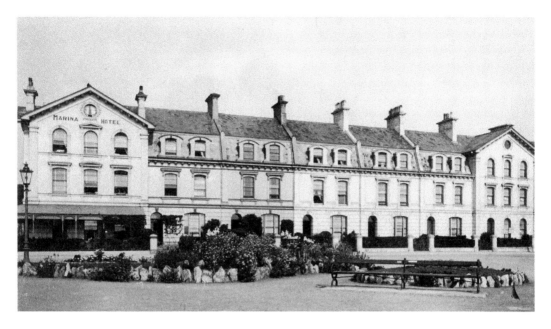

Powderham Terrace, 1920s

The Courtenays of Powderham, lords of the manor of East Teignmouth for four centuries, were responsible for much of the fine architecture along the seafront. Powderham Terrace is a fine early Victorian example. The play park, with its twenty-first-century water features, was installed in 2005.

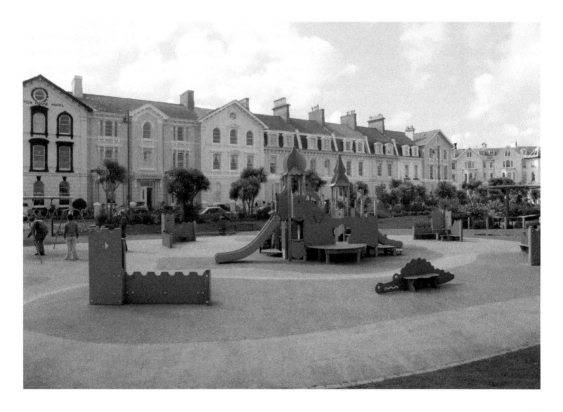

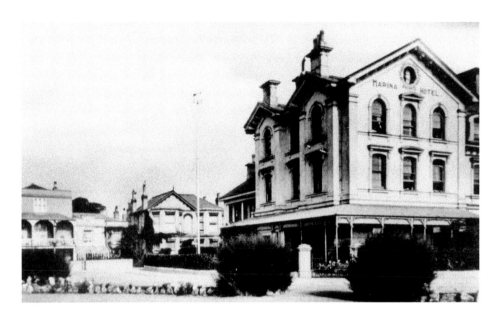

Powderham Terrace, 1920s

Marina Hotel was commandeered in the Second World War for use as a mess for the Royal Navy. Fleet air arm pilots from RNAS Yeovilton were based here whilst training at Haldon aerodrome. The hotel became apartments several years before Leander Court and Morgan's Quay were developed in the 1980s on the adjacent site.

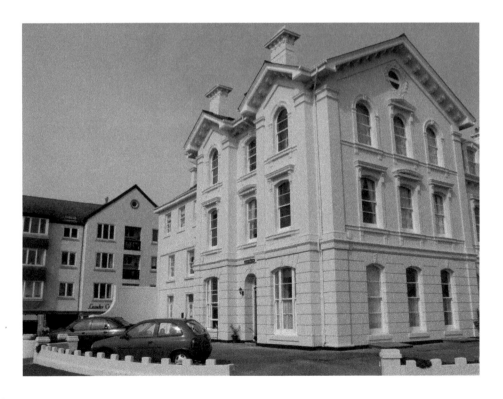

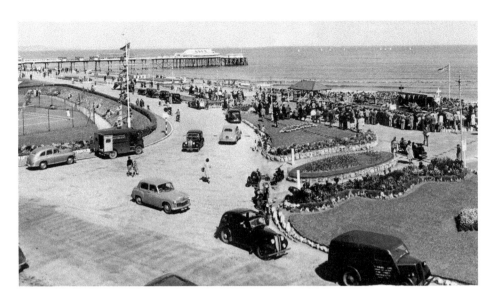

The Den, 1950s

From its earliest days, numerous events have taken place on and around the large open space adjacent to the promenade. Amusements ranged from races with bikes, donkeys and even pigs, to carnivals and regattas. Nowadays, the Upper Den carriageway is closed to vehicles each summer and much of the promenade is given over to raised flowerbeds.

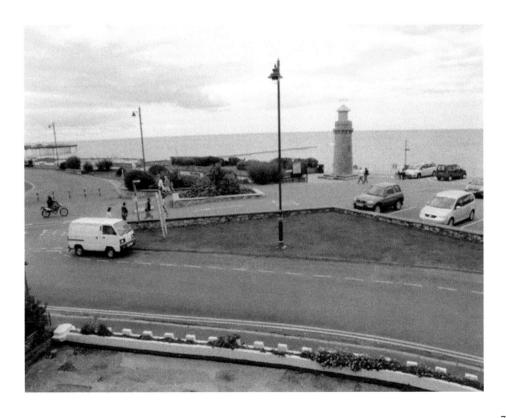

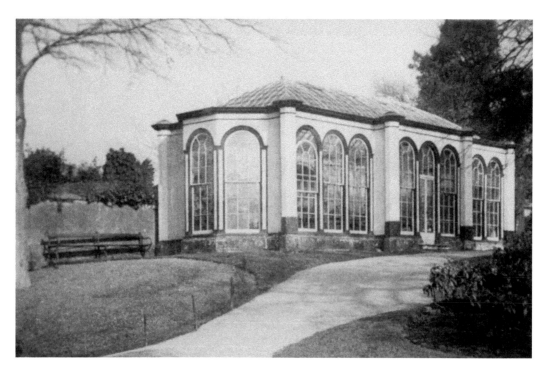

Teignmouth Orangery, Bitton Park, 1930s

Early restoration work revealed a beam marked 1842, dating it later than Admiral Sir Edward Pellew who owned Bitton House and died there in 1833. After buying the estate in 1863, John Parson assisted with Teignmouth's improvements. On 4 July 2009, the Grade II listed structure was officially reopened after a £165,000 refurbishment by Teignbridge District Council. The Friends of Teignmouth Orangery, founded in the mid-1980s, are now leaseholders.

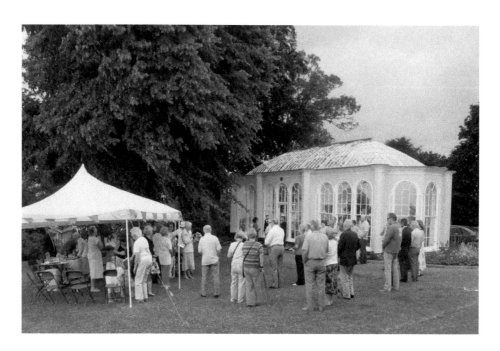

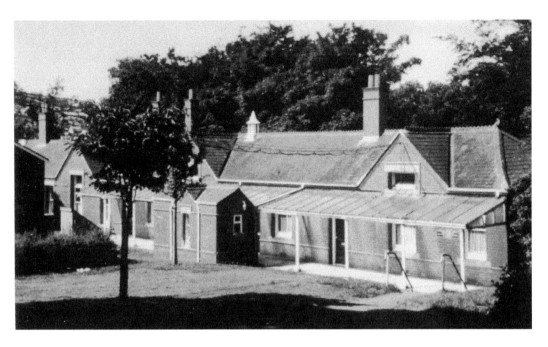

Isolation Hospital, Bitton Park, 1980

People with infectious diseases were wheeled here in the parish chair. No visitors were allowed in the wards, fumigated after patients left – dead or alive. Used for some years as administrative offices by Teignmouth Urban District Council, it was demolished in the 1980s. In its place came Bitton Court, a collection of sheltered homes for local elderly people, opened in 1992.

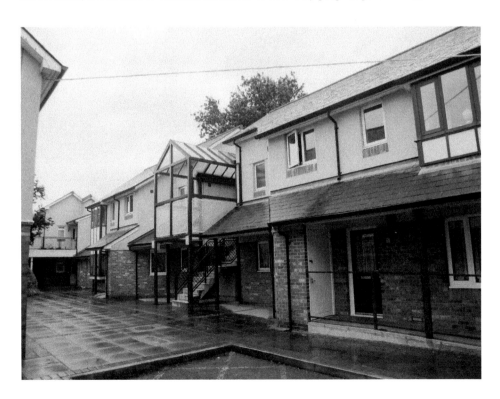

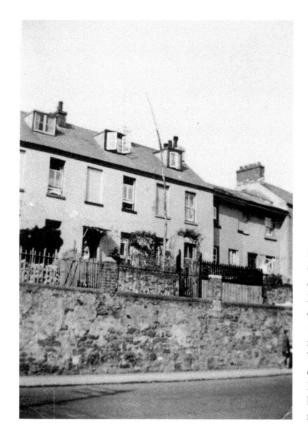

Bitton Terrace, 1950s
Occupying a south-facing position opposite the top entrance to Bitton Park, it was pulled down as part of a road-widening scheme in the 1960s. Its removal exposed the rear of the cottages lining Coombe Vale Road. The name Bitton is derived from Thomas de Bytton, Bishop of Exeter in 1292, who is believed to have spent summer retreats at Lower Bitton.

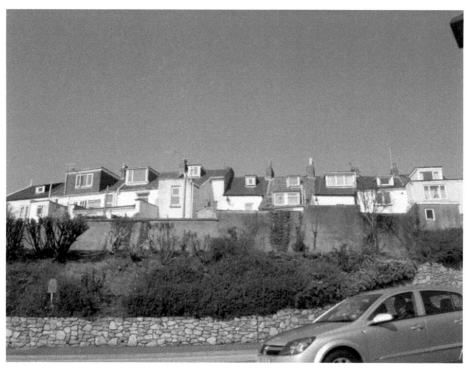

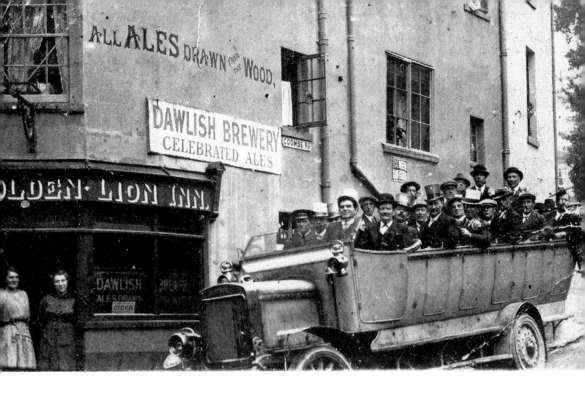

The Golden Lion Inn, 1920s

The inn at the foot of Coombe Road drew all its ales from the wood. Between the wars, Teignmouth had thirty-one public houses for a population of around 9,000 people. It was re-established across the road in the 1950s but did not survive into the twenty-first century.

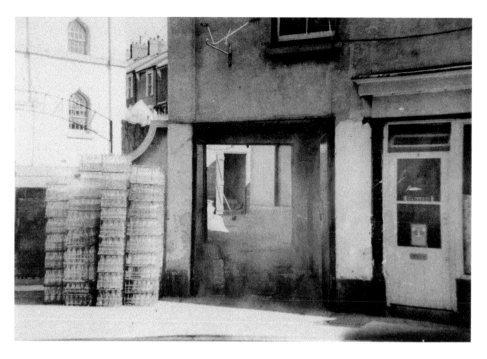

Cocking's Dairy, Bitton Street, 1950s

Milk lorries were obstacles for traffic when the street was a busy thoroughfare and the rattle of glass milk bottles in steel crates woke nearby residents each morning. The dairy became a fish and chip shop after this part of Bitton Street was closed off. Note the unusual ogee-style windows of the Gospel Hall of 1840 where total immersion baptisms still take place.

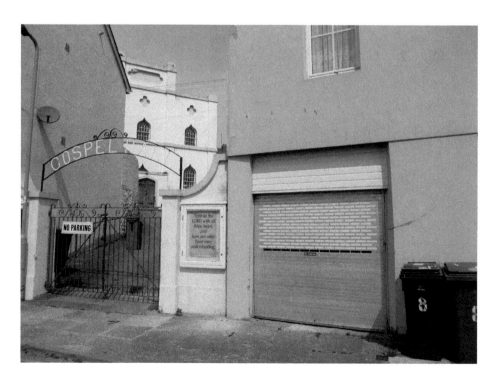

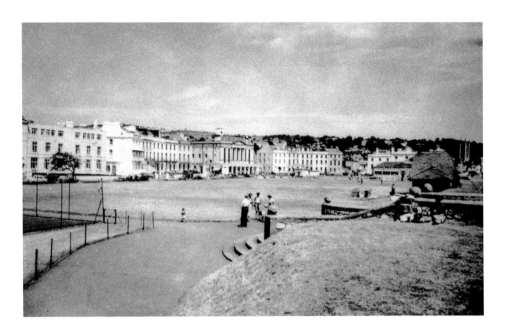

Den, 1953

The new Queen's coronation speech was relayed publicly at The Point. Teignmouth gas works sounded its hooters and Teign Corinthian Yacht Club fired a twenty-one-gun royal salute. Eight tea parties took place for 1,050 children who received a souvenir mug. Despite changes to this end of the Den, the original sets of steps have stood the test of time.

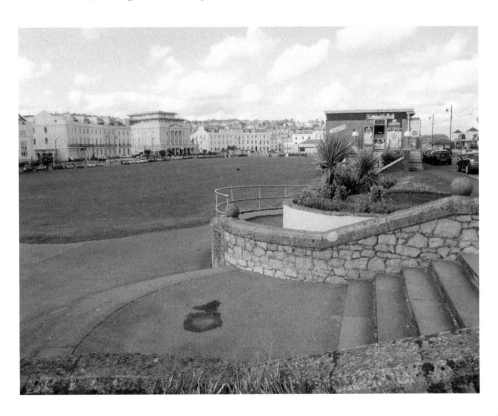

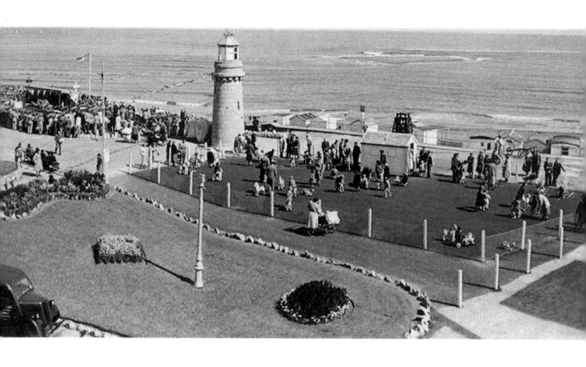

Western Promenade from Powderham Terrace, 1950s

Mobo broncos were a great draw for families that flocked to the resort in the post-war years. The lighthouse's twenty-four mantles and reflectors were once cleaned every two weeks. As it remains important to shipping, the lighthouse of 1845 is kept in good repair by the Harbour Commission. The car park has been extended.

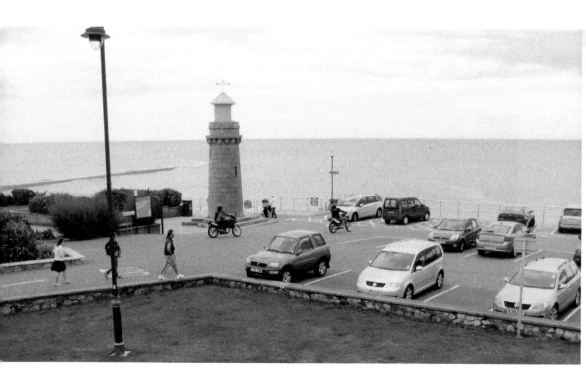

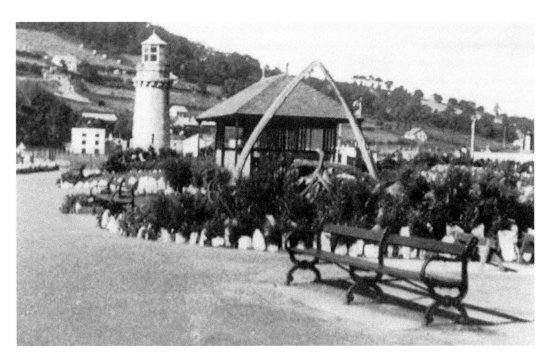

Western Promenade, 1920s

Whale bones were often displayed by sea-going communities in the past. A fort with four guns, 8ft above ground and 110ft in diameter, stood on this site in the 1700s. Manned by volunteers in blue jackets turned back with red, it became neglected after Nelson's victory in 1805. The paddling pool remains a blot on the otherwise pleasant promenade.

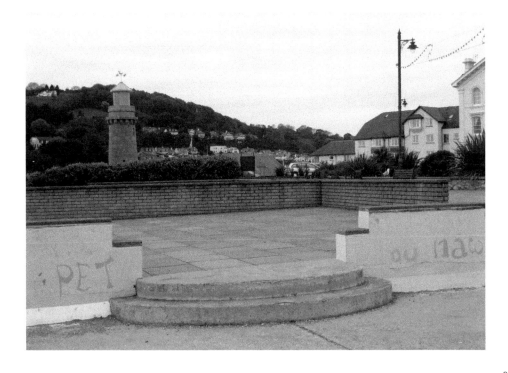

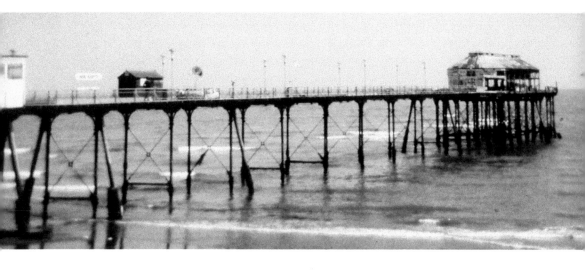

The Pier, c. 1960

Water polo matches staged beside the pier once drew huge crowds, the local swimmers being referred to as veritable 'water rats, as much at home in the sea as on land'. The much-loved ballroom was defunct by the 1960s and eventually demolished but Teignmouth Grand Pier is kept afloat by the Brenner family.

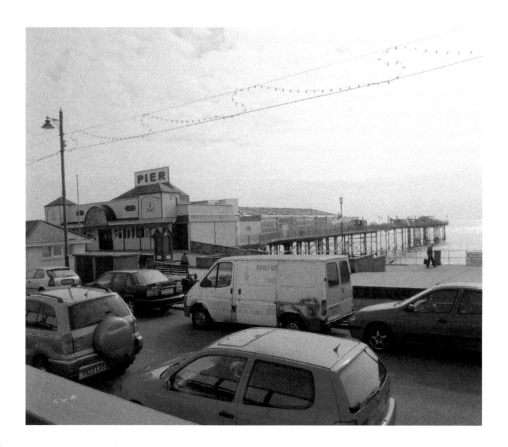

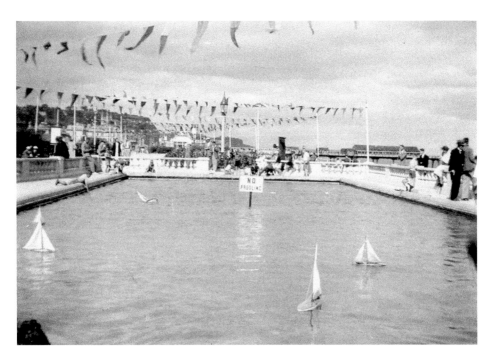

The New Yacht Pool, 1938

The 'No Paddling' sign restricts its use to the sailing of model boats. Post war plans for a 40ft open-air swimming pool with seats, changing rooms and a two-storey café for 150 were never completed. It became a paddling pool and then a swimming pool in the 1970s. In recent times the council declined to spend £50,000 on improvements. It is due to become a skate park.

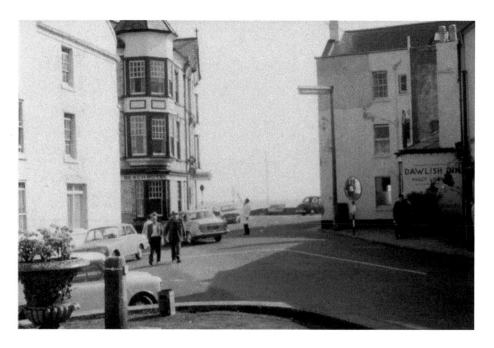

Regent Street, 1964

A white-coated man directs traffic at the foot of two-way Dawlish Street, the large mirror sufficing in his absence. The Belgian urn (left) stands beside the remains of East Teignmouth market cross. The cross has been repositioned and new granite pieces mark Teignmouth's twinning connection with Perros Guirec. The urn now stands next to the Den bowling green.

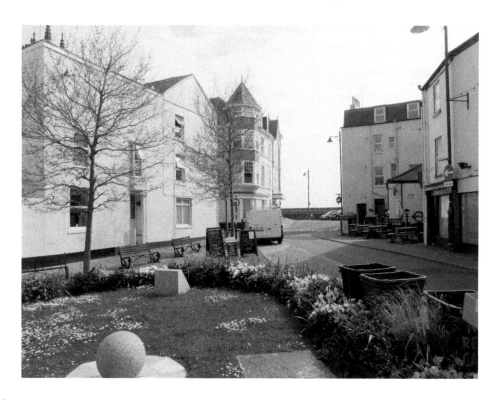

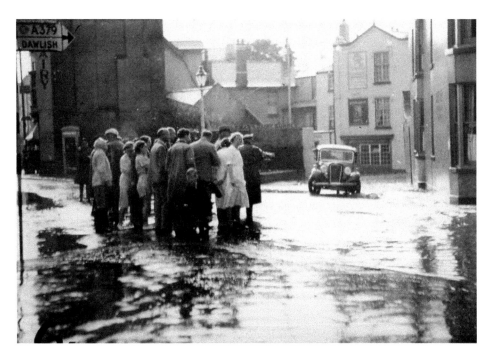

Regent Street Junction with French Street, 1939

The low-lying land was once a marsh. Dawlish Street carried two-way traffic, including the double-decker buses from Exeter that the author travelled on as a child of the 1950s. Recent improvements brought wider pavements and smoother paving slabs to improve this area.

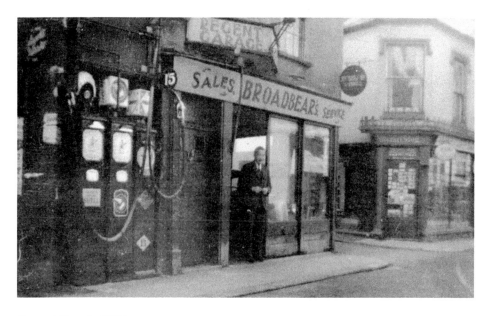

Regent Street, 1930

Businesses across the country began to pick themselves up in the decade following the First World War. Motoring tourists boosted trade at Broadbear's Garage. The garage served as a restaurant for many years and is now a traditional fish and chip parlour. Teignmouth Town Council named the passage between the two buildings The Street with No Name.

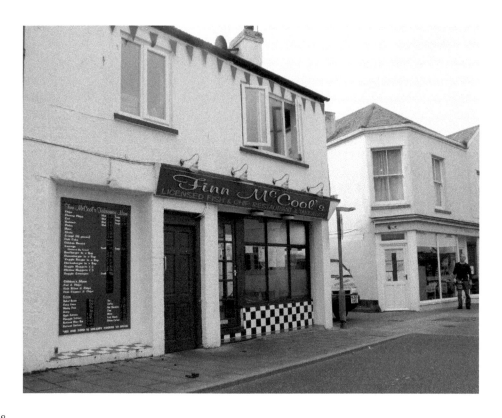

Pound Lane, 2001

Centuries ago, animals brought in for the weekly market were impounded here. The garage business ceased to operate in the centre building and the cleared site has stood empty for over a year. Development plans have been thwarted by difficulties in reaching the bedrock, which is beneath a deep layer of sand on this land, reclaimed from marshes in the 1700s.

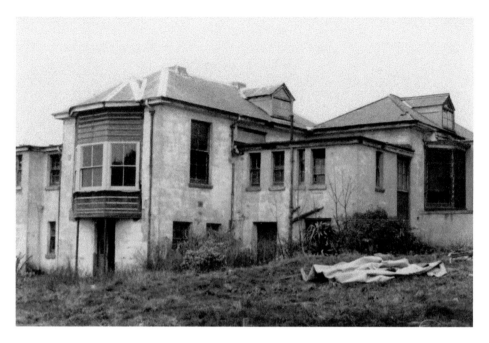

Alberta Mansions' Demolition, 1983

Originally Myrtle House, it was bought mid-nineteenth century by Mr Hennet, a contractor to Brunel's railway. Monks lived in it until their monastery was completed on Buckeridge (1879) and it was the town's first hospital. A fine new wall was built to protect the southern boundary of Alberta Court of 1984, which consists of warden-attended homes for elderly people.

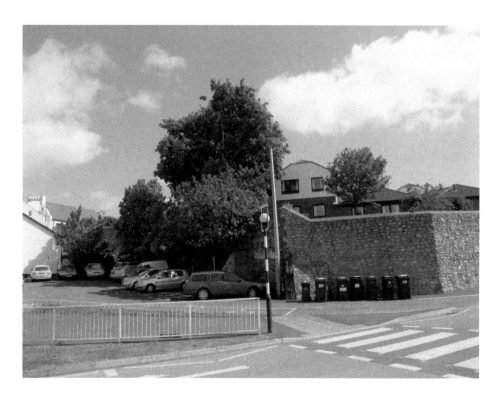

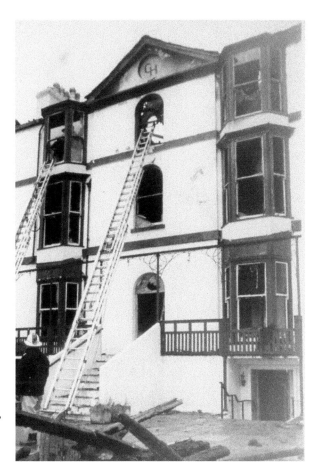

Clifton House, 1989
The dilapidated old house standing next to St Michael's church caught fire one winter night. The replacement building, inspired by the original design, is made up of several purpose-built flats.

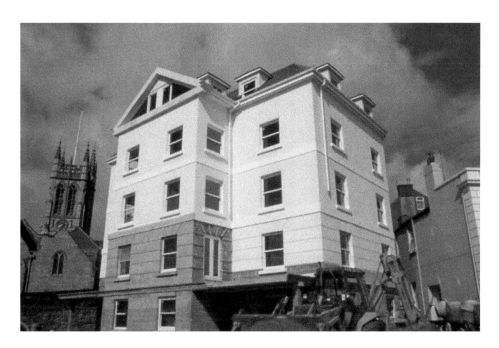

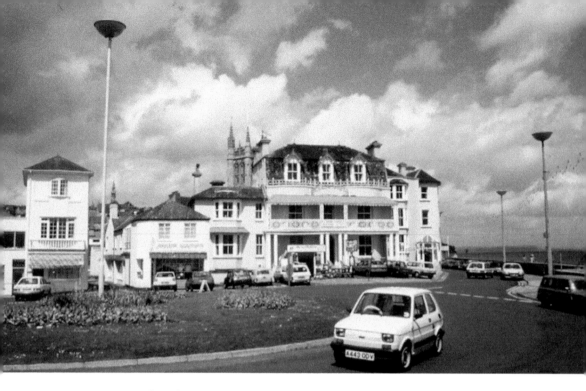

Den House, Esplanade, 1986

This was one of five academies in Teignmouth where young ladies were 'finished' in the 1820s. Altered to private apartments for holidays early in the twentieth century, it had a significant upgrade in 1995, about the same time as the roundabout was eradicated. The new Disability Act prompted provisions for disabled people to be built into the sea defence wall.

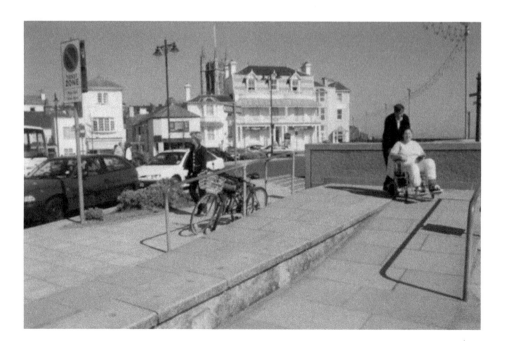

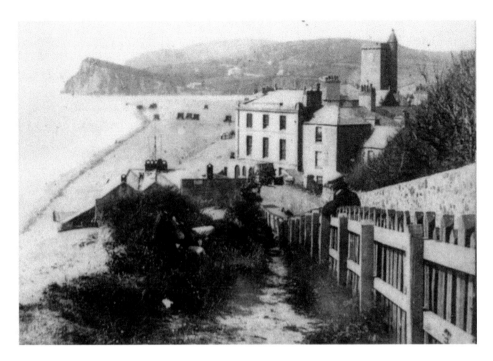

Eastcliff, pre-1879
The image dates from before the railway tunnel beneath was opened into a cutting (1879-1881). Public baths stand at the foot of the path. The coastguard station built here later was bought by the council for £50 in 1951. Teign Corinthian Yacht Club's new HQ, built on the roof of the 1937 Jubilee shelters, was opened in 1997 by Sir Robin Knox Johnston, the first person to sail non-stop and single-handed round the world.

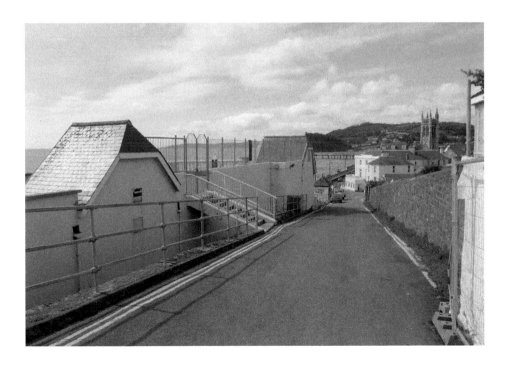

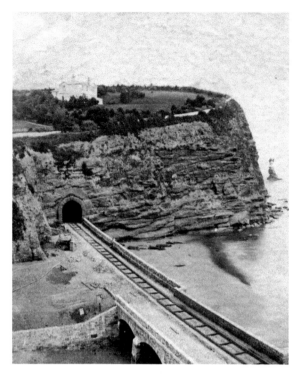

Parson & Clerk Rocks, c. 1890
The single, broad gauge railway
line emerges from the tunnel
at the foot of Smugglers Lane.
The tunnel was widened when
the track was replaced in 1892.
The three-funnelled *Queen Mary*
crossed the bay on her maiden
voyage to New York in 1936.
Clerk Rock lost its head in recent
years. The glowing cliffs are
beautiful, but the soft, porous
nature of Old Red Sandstone
is fragile. Time, tide and global
warming are collectively
re-drawing the coastline.

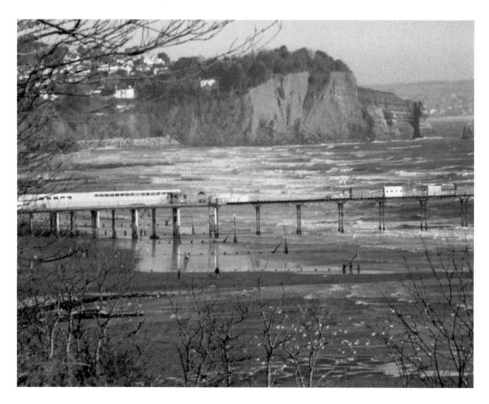

Random Thoughts

June 1986. Presented film show *Welcome to Teignmouth* at Carlton Theatre for holidaymakers and a few locals, including a lady who does B&B in Brunswick Street. She put me in touch with a Teignmouth postcard collector, Arthur Smith.

July 1986. Looked through Arthur's 3,000 photos and postcards of this area. Inspired to start my own collection.

April 1987. Evening walk in Eastcliff Meadows. The Dell is like a primeval forest. Must photograph it to use in opening sequence in my new film show.

September 1992. Chips Barber, a new publisher from Exeter, invited me to put a little book of Teignmouth old photographs together – *From Teignmouth – With Love*.

October 1994. Moved into Bridge View beside the river. Town life – the new experience!

October 2000. Launched first self-published book, *Teignmouth at War*.

May 2004. Walked the dog along First Drive and saw Greenbanks being gutted and turned into flats. More and more new flats are going up. Teignmouth is changing.

January 2005. The London Hotel has closed. More flats!

November 2007. Leapt into twenty-first century by going digital with photography and videography. My shows will never be the same again! Enthusiastic response – maybe I will do a follow up.

January 2009. Started work on *Teignmouth Through Time* – a new book for Amberley Publishers. It's getting harder to match views due to vegetation, buildings and, now, recycling boxes and wheelie bins. This is definitely going to be my last book!

Viv Wilson, MBE

Acknowledgements

For loaning photographs and supplying information
The People of Teignmouth for their unfailing support
Teign Heritage • Ken Bennett • Ted Collins
Peter and Darren Fogden • Brian & Jenny Harris
The Jones Family of Essex • Michael Markham • Tim Peat
Cllr Sylvia Russell • Jim & Eileen Stowers • Arthur L Smith
John Silverman • Edie Trankle • John Wise • Cllr David Weekes
The late Alfred Burgess • The late Elizabeth & Reginald Lewis
Tim Woodward for technical assistance.

Special Thanks to Helen Bee for continuous assistance and
encouragement throughout the project and for proof reading.